LEGENDARY L(

OF

SEDALIA

MISSOURI

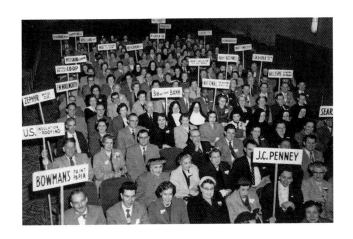

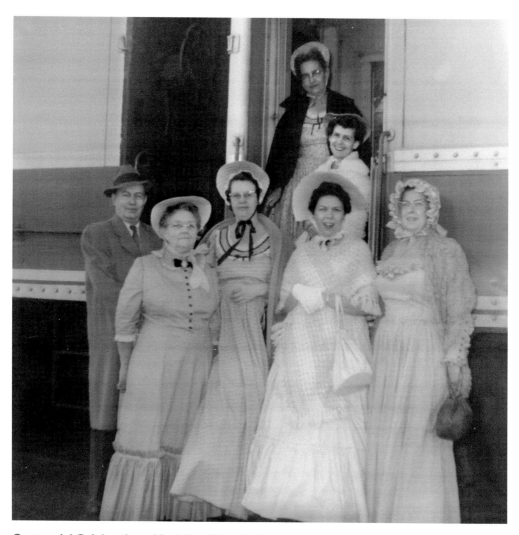

Centennial Celebration of Sedalia's First Train
In January 1961, Leslie Hale organized an event to celebrate the 100th anniversary of the arrival of Sedalia's first train. Pictured with the Missouri Pacific Eagle from left to right are (first row) Leslie Hale, Cleo Maxwell, Mary Rouchka, Martha Farley, and Irene Dirck; (second row) Shirley White and Marie Wiemholt. They traveled to Jefferson City and rode the train back to Sedalia, where 2,000 people gathered at the Missouri Pacific depot for the celebration. (Courtesy of Millicent Hale.)

Page 1: Educators and Businesses
In the mid-1950s, the Sedalia Chamber of Commerce sponsored events to honor local educators. Teachers and administrators are pictured at the Fox Theatre holding signs representing local businesses. Many of these businesses remain in Sedalia—along with the educators' influence. (Courtesy of Sedalia Public Library.)

LEGENDARY LOCALS
—— OF ——

SEDALIA
MISSOURI

REBECCA CARR IMHAUSER

LEGENDARY
LOCALS

Legendary Locals is an imprint of Arcadia Publishing
Charleston, South Carolina

Printed in the United States of America

Library of Congress Control Number: 2012942264

For all general information, please contact Arcadia Publishing:
Telephone 843-853-2070
Fax 843-853-0044
E-mail sales@arcadiapublishing.com
For customer service and orders:
Toll-Free 1-888-313-2665

Visit us on the Internet at www.arcadiapublishing.com

Dedication
This book is dedicated to my parents, husband, and children: Leonard and Betty Singer, Bill Imhauser, and Joe and Leah Carr. Their support and patience made it possible.

On the Cover: From left to right:
(TOP ROW) Jackie Oakie, actor, with Sandra Hammond and Helen Eschbacher, Sedalia Centennial Queens (courtesy of Sedalia Public Library, see page 94); Ruth Ann Archias, Archias Floral Company (courtesy of Leon Keens, see page 51); Ruth Bockelman, Orville Shaw, and Harmonicat, musicians (courtesy of Ruth Bockelman, see page 97); Iva Rice, Old Missouri Homestead Restaurant (courtesy of Bobbie Rice Franklin and Betty Rice Schlotter, see page 69); John Homer Bothwell, businessman and philanthropist (author's collection, see page 58).
(MIDDLE ROW) Ron Jennings, newspaper reporter and author (courtesy of Pat Jennings, see page 82); Henry Wilson Harris and Leona Boggs Harris, Third National Bank (courtesy of Jane Harris Yount, see page 52); Leo Lewis and Pokey, post office (courtesy of Leo Lewis, see page 20); George Lingle, journalist (author's collection, see page 16); Mayor Julian Bagby and Walter Dobel, Milton Oil (author's collection, see page 73).
(BOTTOM ROW) D. Kelly Scruton, journalist (author's collection, see page 16); Jennie Jaynes Lewis, philanthropist (courtesy of Bothwell Lodge State Historic Site, Missouri State Parks, see page 36); George R. Smith, Sedalia founder (author's collection, see page 10); Dr. Albert R. Maddox, physician (author's collection, see page 14); George Whiteman, namesake for Whiteman Air Force Base (author's collection, see page 122).

CONTENTS

ACKNOWLEDGMENTS

This book could not have been written without the generosity of those who shared photographs. Their names appear throughout the book along with the images they provided. Other images are courtesy of the author.

In addition to sharing photographs, some contributors penned narrative. I extend my thanks to Jack Clark, Erica Eisenmenger, Maxine Flores, Pat Jennings, James Jonson, Richard Parkhurst, and Deborah Silberstein Stoeckle for providing the perfect words to describe your legendary locals.

This book began with a list of names. It would have remained such without those who helped obtain access to archives, acquire photographs, identify people, and facilitate content review. Thank you to the following for their expert guidance: Gayle Allen, Barbara Bishop, Charles W. Bolton, Lucy Bolton, Becky Carver, Greg Cecil, Dr. Rhonda Chalfant, David Christopher, Tom Christopher, Marissa Cowen, Tom Darrah, Linda Fisher, Ann Graff, Mary Frances Herndon, Pam Hunter, Tom Hurley, Susan Kromrie, Shirley McCown, Mary Jo McMullin, Becky Munson, Jason Myers, Bob Overstreet, Jon Parkhurst, Nicole Polk, Stan Ragar, Jack Robinson, Michelle Malone Shepard, Arlene Silvey, Jack Slocum, Aric Snyder Jr., Tom Taylor, Pam Tull, Jay Van Dyne, Vic Van Dyne, Jennifer Volck, Kevin Walker, Charles W. Wise, Julie Vinson Wiskur, and Laymon and Ru Wolfe.

I wish also to thank my editor at Arcadia Publishing, Tiffany Frary, who delivered her own legendary locals—twins!—while I was laboring over this book's manuscript. I appreciate her expertise, insight, and responsiveness.

My deepest and ongoing appreciation to those who have walked with me through this and previous books, providing a wealth of information, answering a myriad of questions, and offering endless encouragement: Anna Lee Bail, Millicent Hale, James Keck, Mary McLaughlin, and Jane Harris Yount.

Finally, a special thank-you to my writing partner and mother, Betty Wasson Singer. Now it's your turn, Mom, for your next book.

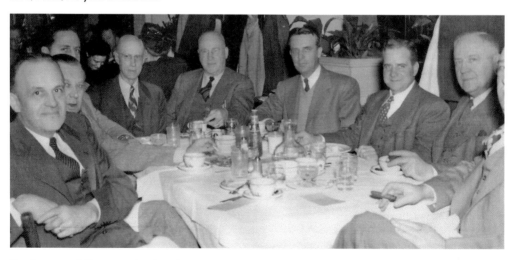

Business and Community Leaders
These men who dined in the Bothwell Hotel Coffee Shop in 1947 represented an array of Sedalia professions and leadership positions. From left to right are Herman E. Bloess Sr. (Looney-Bloess Lumber Company); Heber U. Hunt (Sedalia School District); J.R. Van Dyne (Adco); Frank W. Bryant (Bryant Motors); Jacob E. Smith (judge); Thomas W. Cloney, (Dorn-Cloney Laundry); John Martin (attorney), and Don Lamm Sr. (attorney). (Courtesy of Jack Bloess.)

INTRODUCTION

This is the hardest book I've ever written. I embraced the assignment to highlight people who had shaped Sedalia's history and are continuing to do so. But when I started assembling a list of these people—and the list kept growing and growing—I realized my predicament. My first pass at this book had enough content for three volumes. I then reexamined my assigned ratios of deceased legendary locals (80 percent) and current ones (20 percent). My list of people grew even longer. This "problem" is the very reason I love Sedalia: Our community abounds with legendary people.

The story of Sedalia began more than 150 years ago. Its future title—"Queen City of the Prairies"— would have seemed far-fetched to those who first traipsed its rutted, dusty roads. In 1856, George R. Smith borrowed money from Fayette McMullen to purchase 337 acres of treeless prairie from Absalom McVey. Smith was convinced his city held the promise of becoming a railroad terminus. This was an asset he had been unable to secure for the then–county seat, Georgetown.

When Smith could not convince the people of Georgetown to invest in bringing the railroad to the city, he started his own town. October 1860, the date of Smith's first successful auction of city lots, is now considered the official beginning of the city. The arrival of the first passenger train through town in January 1861 sealed the deal.

Three months after the first train rolled through Sedalia, the Civil War began. The new city's promising growth came to a screeching halt. I. Mac Demuth quoted an original Sedalia resident as saying, "Not a nail was driven after the first of May 1861. Building ceased, and some merchants left."

Just as the beginning of the Civil War interrupted Sedalia's development, its end spawned growth in a new way. Some who had been stationed in Sedalia during the Civil War returned to settle and open businesses. Others followed. The 1873 city directory applauded Sedalia's status: "It is now the chief agricultural, commercial, manufacturing, and railway centre—the chief metropolis of this portion of the state—containing over 8,000 of as enterprising, public spirited, energetic, and intelligent inhabitants as can be found in any city of its size in the United States."

The city's growth was not without disappointments. Pettis Countians launched a vigorous campaign to have the Missouri state capital moved from Jefferson City to Sedalia. Despite their best efforts, a statewide vote in 1896 determined the Missouri capital would remain in Jefferson City.

While Sedalia lost the capital, it gained ragtime music. Scott Joplin, who lived in Sedalia during the 1890s, played piano at the Maple Leaf Club. Joplin, hailed as "the King of Ragtime," contracted with Sedalia music storeowner John Stark to publish the "Maple Leaf Rag" in 1899. More than a century later, ragtime still rings on Sedalia streets. Sedalia has hosted the Scott Joplin International Ragtime Festival annually since 1983.

The city's upswing continued into the next century, fueled by the dual acquisition of the Missouri State Fair and expansion of the Missouri Pacific Shops in the early 1900s. The fair remains a significant part of Pettis County, with grounds that attract events and visitors year-round. The Missouri Pacific and Katy Railroad shops served as major employers for Sedalia until the 1950s and 1960s.

Downtown Sedalia roared through the Roaring Twenties, beginning with a fire that destroyed its majestic courthouse in 1920. A new $350,000 courthouse was completed in 1925, followed by the Hotel Bothwell, another landmark, to its north in 1927. The city ended the 1920s on a promising note. Two of its downtown banks erected entirely new buildings in 1929, and two others completed significant remodeling. Unfortunately, three of these four banks closed between November 1931 and February 1932.

Life magazine declared Sedalia the city second-hardest hit by the Great Depression in the entire United States. Buildings reflected the times. Towering structures built during prosperity were decapitated to reduce taxes. On a more positive note, the John H. Bothwell Memorial Hospital opened in 1930. Now Bothwell Regional Health Center, the hospital has satellite clinics in Sedalia as well as other cities. Guy

Snyder founded Inter-State Studio, now North America's largest family-owned school photography and yearbook publishing company, in 1933.

The 1940s and 1950s—eras of postwar prosperity—brought new life to Sedalia. Homes could not be built quickly enough to house returning soldiers and others who moved to the area. Town and Country Shoes, Parkhurst Manufacturing, Rival Manufacturing, and Pittsburgh-Corning Corporation are just a few of the major industries that sprang up during this era.

Sedalia's turbulent 1960s mirrored the unrest in the nation. Its retail center moved from downtown to two shopping malls constructed in the middle part of the decade. The city experienced major changes on the educational front as well. State Fair Community College opened in 1968, exactly one century after the city had constructed its first public school.

Without a doubt, the Ozark Music Festival was Sedalia's most memorable event during the 1970s. More than 150,000 people poured into town in July 1974 for the three-day rock festival, sometimes called the "Woodstock of the Midwest." A swarm of people overtook the Missouri State Fairgrounds and spilled into nearby commercial and residential areas. Despite the fact that big name bands performed, most locals remember the event for its drugs and nudity.

Industrial development experienced a resurgence in the late 1960s and 1970s, replenishing jobs lost when the railroad shops closed. Alcan Cable, American Compressed Steel, Duke Manufacturing, Kelsey Hayes, Gardner-Denver, Waterloo Industries, Septagon, Fantasia Multifoods, and Payless Cashways became major employers. Many remain in the area, continuing to contribute to Sedalia's economy. In more recent years, Tyson Foods, Starline Brass, Sierra Bullets, and Pro-Energy have become major area employers.

While Sedalia has changed enormously since its founding more than 150 years ago, its substance remains—its people. Philip McLaughlin, business owner and civic leader, reminded the city of its most important asset in 1965. "We have heard many things about the advantages and disadvantages of our community," McLaughlin said to viewers on Sedalia's KMOS-TV. "There is one advantage that has not been stressed. It is the spirit of Sedalia people . . . It is the spirit of the people that made Sedalia, and it is the spirit of the people that will bring us through every trial, and it is the Sedalia spirit that will bring a good future to us."

As you read this book, I hope you will reminisce about those who represent the "Sedalia spirit" to you. While they might not appear in this book, they are tucked in your heart. I hope this book prompts you to let them know, if possible, how much you appreciate their example. And I hope it helps you realize that you are the keeper of the Sedalia spirit—in whatever community in which you reside—through the life you lead and the lives you touch.

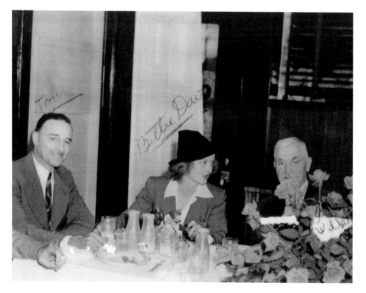

Community Patriotism Film star Bette Davis visited Sedalia in 1942 to promote war bond sales. She is pictured at the Hotel Bothwell with Tom Yount (left), chairman of the Bonds for Victory Drive, and Sedalia mayor A.H. Wilks. After Davis spoke at a rally at Smith-Cotton High School, the two-time Academy Award winner was presented with a third "Oscar"—a Missouri donkey named Oscar. (Courtesy of Jane H. Yount.)

CHAPTER ONE

Foundations and Beginnings

Sedalia's foundations are built on an unlikely scenario—one man's bad luck. George R. Smith approached age 30 cash-strapped and in a quandary about his future. The financial depression of 1828–1829 had wiped out his reserves. Ready for a fresh start, Smith moved his wife and young daughters from Kentucky to Missouri in 1833. They joined a caravan led by David Thomson, Smith's father-in-law. Seven hundred miles and nearly six weeks later, they reached Missouri and settled in Pin Hook, a few miles north of what is now Sedalia. The Thomsons and Smiths soon moved a few miles west to an area Thomson named Georgetown, after his hometown in Kentucky, and built brick houses and an elaborate brick courthouse. By all rights, Georgetown appeared to prosper. The people were comfortable—so comfortable, in fact, that they did not understand Smith's passion for embracing the burgeoning railroad. He was so passionate he started his own city: Sedville, or Sedalia. Few dared to move to what they considered Smith's experiment. And when they did, they settled on the northern edge of town. They remained poised for a hasty exit to Georgetown should Sedalia fail. The outlook for Smith and Sedalia improved drastically in March 1859 when the Pacific Railroad agreed to place a depot on Smith's land. His naysayers then became believers—and the new town began to develop. The foundations established in Sedalia's early years provided a firm basis upon which to build the city. Transportation, medical care, newspapers, fire, police, library, and utilities were represented. But without people, these are mere words that describe systems and organizations. This chapter features some of the people who laid foundations for the new city of Sedalia, foundations that continue to sustain more than 150 years later.

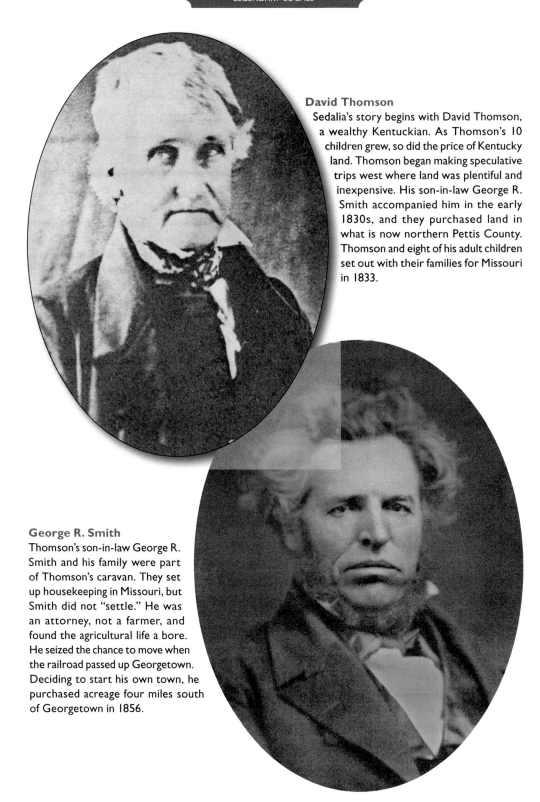

David Thomson

Sedalia's story begins with David Thomson, a wealthy Kentuckian. As Thomson's 10 children grew, so did the price of Kentucky land. Thomson began making speculative trips west where land was plentiful and inexpensive. His son-in-law George R. Smith accompanied him in the early 1830s, and they purchased land in what is now northern Pettis County. Thomson and eight of his adult children set out with their families for Missouri in 1833.

George R. Smith

Thomson's son-in-law George R. Smith and his family were part of Thomson's caravan. They set up housekeeping in Missouri, but Smith did not "settle." He was an attorney, not a farmer, and found the agricultural life a bore. He seized the chance to move when the railroad passed up Georgetown. Deciding to start his own town, he purchased acreage four miles south of Georgetown in 1856.

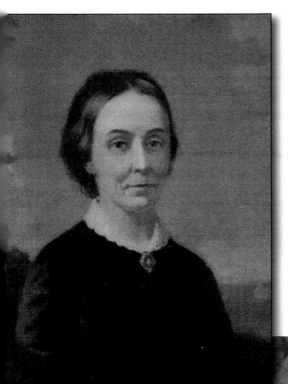

Melita Thomson Smith

George R. Smith always credited his wife, Melita, for his success in life. "If it had not been for her, I should not have been worth anything, either morally or financially," he said 15 years after her death. "She had more wisdom than any woman I ever knew." Melita Smith died in April 1861, the same month the Civil War began.

Sarah Smith-Cotton and Martha Smith

George R. Smith named his new city after his youngest daughter, Sarah, or "Sed" (right), since he already had named a boat after his older daughter, Martha (second from left). Shortly after selecting the name Sedville, a friend suggested the suffix "-alia," in keeping with larger cities. After her parents' and sister's deaths, Sarah donated land for the Smith-Cotton High School, now Smith-Cotton Junior High.

William Johnson

"I've Been Working on the Railroad" could have been Johnson's theme song. Pictured in the early 1870s, Johnson represents the scores of men who moved to Sedalia for jobs on the Pacific (later Missouri Pacific) or Missouri-Kansas & Texas (MK&T, or Katy) railroad. Both lines had major shops in Sedalia. Johnson worked as a fireman for the Pacific Railroad.

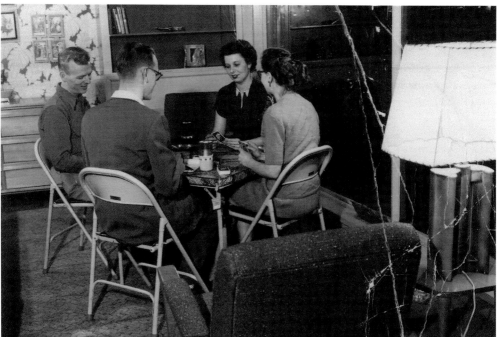

Railroad Activities

While railroads were a major employer, Sedalians did more than work on the railroad. Railroad shops provided foundations for community support and entertainment. Members of the Missouri Pacific Women's Club sponsored "Living Windows," during which people became live mannequins in store windows. Kenneth Dick (left) and Marva Dick joined another couple in demonstrating a card table and chairs at Callies' Furniture. (Courtesy of Jack McMurdo.)

Dr. John W. Trader

After serving as a surgeon in the Civil War, Dr. John W. Trader moved to Sedalia in 1866. He served as president of the Missouri State Medical Association and was appointed surgeon for the MK&T Railroad. Dr. Trader built an ornate home and medical office on South Osage Avenue, which later served as a sanitarium operated by him and Dr. W.G. Cowan. (Courtesy of Sedalia Public Library.)

Fifty-Year Physicians

Dr. John Trader's son Dr. Charles B. Trader was one of four physicians recognized in 1951 for completing 50 years in the practice of medicine. The Pettis County Medical Society honored the following with a dinner at the Old Missouri Homestead, from left to right: Drs. W.T. Bishop, C.L. Parkhurst, unidentified, Charles B. Trader, and J.E. Cannaday.

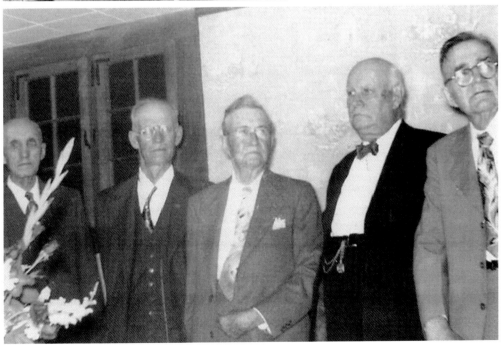

13

Dr. John Tobias
An 1848 graduate of the Jefferson Medical College in Philadelphia, Dr. Tobias moved to Sedalia before the end of the Civil War. He helped organize the Ohio Street Methodist Church and was a member of its "amateur band of singers" that performed for picnics. He was elected vice president of the newly formed fair association in 1866 and also served on the school board and as a city officer.

Dr. Albert R. Maddox
In addition to his private practice on West Main Street, Dr. Maddox was presiding physician and superintendent of City Hospital No. 2 for African Americans. He served the Sedalia area for more than 50 years, receiving the Outstanding Citizen Award from the Sedalia Chamber of Commerce in 1981. He passed away in 1985 at age 86.

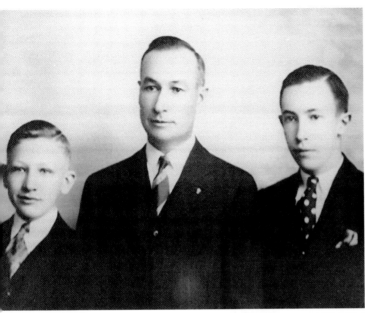

The Gouge Legacy

Since 1915, three successive generations of the Gouge family have maintained veterinary offices on West Main Street. It is the oldest practice in Missouri and is believed to be the oldest continuing veterinary family practice at the same facility in the United States. Founder Dr. Mord E. Gouge is pictured with his sons Dr. Hardin E. Gouge (left) and Dr. Robert E. Gouge. Dr. Robert N. Gouge, son of Robert E. Gouge, is the current owner-practitioner of the G&G Veterinary Hospital. (Courtesy of Dr. Robert N. Gouge.)

Dr. Benjamin Klein

After World War II, Dr. Benjamin E. Klein returned to Sedalia. He practiced dentistry for 49 years, located for decades in the Klein Building at 614 South Ohio Avenue. Being a caring, personable, and dedicated dentist, Dr. Klein also was the charter president of the Sedalia Optimist Club and president of the Sedalia Symphony. He was married to Louise Klein, who was active in the Sedalia Little Theater and the Helen G. Steele Music Club. (Courtesy of Shirley Klein Kleppe.)

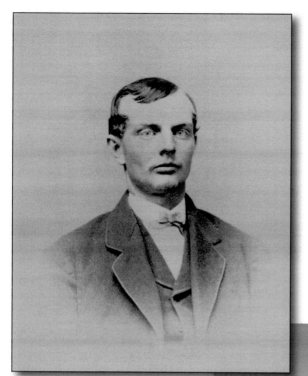

George Lingle
George Lingle never forgot his first night in Sedalia. "Our sleep was short—disturbed by an invasion of bed bugs. There was no alternative but to give quiet and undisputed possession," Lingle said of his room. He moved to another building that night and founded Sedalia's first newspaper, the *Sedalia Advertiser*, in August 1864—just in time for one of Sedalia's biggest scoops: Confederate forces invaded the city the following month.

D. Kelly Scruton
The Scruton family was synonymous with Sedalia newspapers. George H. Scruton Sr. became editor and manager of the *Sedalia Sentinel* in 1903 and later was editor and owner of the *Sedalia Democrat*. His sons George H. Scruton Jr. and D. Kelly Scruton began their careers as carriers and later became editors of the *Sedalia Democrat* and the *Sedalia Capital*. D. Kelly Scruton is fondly remembered for his ever-present cigar and camera, as well as his work with the Lions Club.

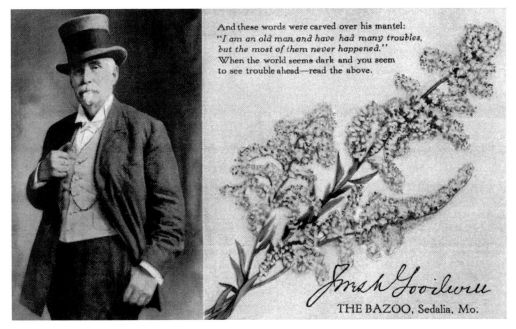

And these words were carved over his mantel:
"*I am an old man and have had many troubles,
but the most of them never happened.*"
When the world seems dark and you seem
to see trouble ahead—read the above.

THE BAZOO, Sedalia, Mo.

J. West Goodwin

For more than six decades, J. West Goodwin was a larger-than-life figure in Sedalia publishing. He issued Sedalia's first daily newspaper, the *Bazoo*, in 1869. Goodwin published a daily newspaper until 1896 and distributed a monthly magazine until a few weeks before his death in 1927—the day after his 91st birthday.

Living Windows

J. West Goodwin "returned" to Sedalia more than 80 years after his death. Through the acting artistry of J.R. Walter (right), Goodwin starred in "A Sedalia Christmas," a multimedia holiday production written by Becky Imhauser. The show about Sedalia's Christmas heritage premiered at the Liberty Theatre in 2008. Walter portrayed Goodwin during downtown Sedalia's Living Windows while Dr. Jerry Harlan greeted spectators.

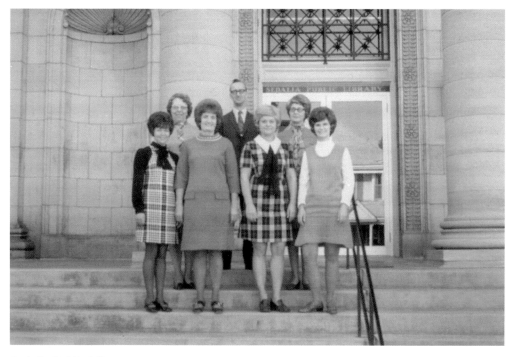

Sedalia Public Library
Exactly a century after the Sedalia Library Association was organized in 1871, the staff of the Sedalia Public Library posed on the library's front steps. Pictured in 1971 are (first row) Alberta Harrell, Lucille Bechtel, Jane Williams, and Margaret Dowdy; (second row) Elaine Keele, Don Morton, and Connie Goodier. The present Greek Revival library at 311 West Third Street was completed in 1901 through a $50,000 grant from Andrew Carnegie. (Courtesy of Sedalia Public Library.)

Catherine Scott
Books and arts were among Catherine Scott's passions, and she remembered both with gifts following her death in 2010. A portion of Scott's estate was donated to Boonslick Regional Library, where she worked from 1953 to 2004. Scott was also a gifted painter and avid supporter of the arts. Her estate included a bequest to the Daum Museum of Contemporary Art. (Courtesy of Pam Tull.)

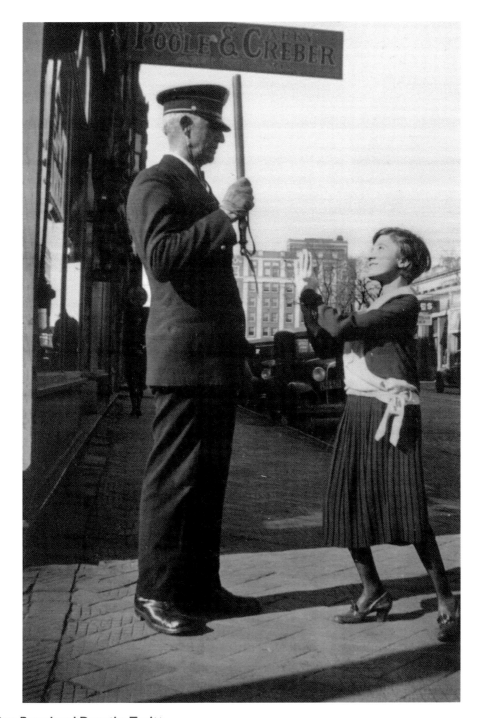

Dan Byard and Dorothy Truitt
In a departure from his usual beat, Dan Byard "arrested" a hobo on Ohio Avenue. The hobo actually was Dorothy Truitt, taking part in Smith-Cotton High School's Hobo Day. Students spent the day downtown "begging" from merchants before being treated to a special event at a theater. Smith-Cotton High School held an annual Hobo Day until 1932, when Frolic Day replaced it. (Courtesy of Sedalia Public Library.)

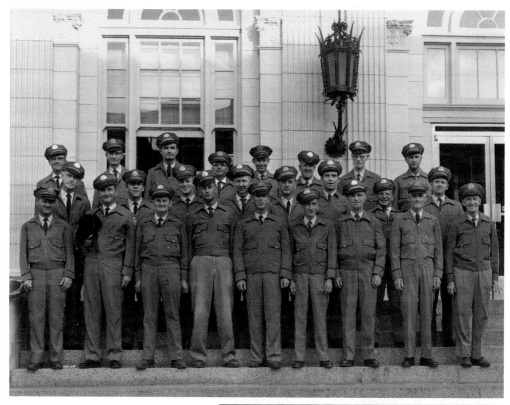

Leo Lewis and Pokey

Pokey, a Cocker Spaniel–Pekinese puppy, started following Leo Lewis (first row, second from left) in 1960. She quickly made friends with postal employees as well as customers along Lewis's mail route. Pokey sometimes became tired in the afternoon, having covered several miles with her short legs. By this time, Lewis had delivered most of the mail and gave Pokey a lift in his mailbag. When Lewis finished his shift, he dropped Pokey off at her home before returning to his. After Pokey had accompanied Lewis for nine years, her owner, Bill Birch, was transferred to Kansas City. Pokey moved but continued to wait each day on the sidewalk for Lewis—until Birch asked Lewis if Pokey could return to Sedalia and live with him. Lewis, of course, agreed. Pokey was back on the mail route until she passed away in 1972 at age 14. (Both photographs courtesy of Leo Lewis.)

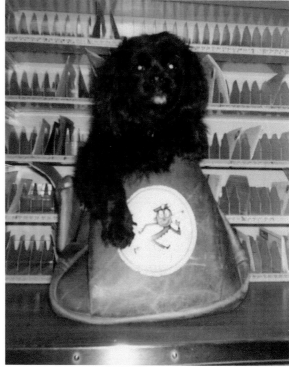

Lewis P. Andrews
Sedalia's public water supply dates to 1872, when the city completed its $120,000 waterworks plant south of town on Flat Creek. Lewis P. Andrews was president and manager of the Sedalia Water Company from 1900 to his death in 1939. Educated as an engineer, he began his career with the railroad. He also built waterworks and electric plants in Missouri, Kansas, Arkansas, and Mexico. (Courtesy of Lewis P. Andrews III.)

Telephone Company Employees
Jennie Cooper (front left) and Bessie Turner (front right) were honored for 40 years of service with Southwestern Bell in 1949. They began working for the phone company shortly after it moved to a new building at Third Street and Lamine Avenue, where it remained until 1957. The Traffic Department of the phone company hosted this celebration at the Old Missouri Homestead Restaurant.

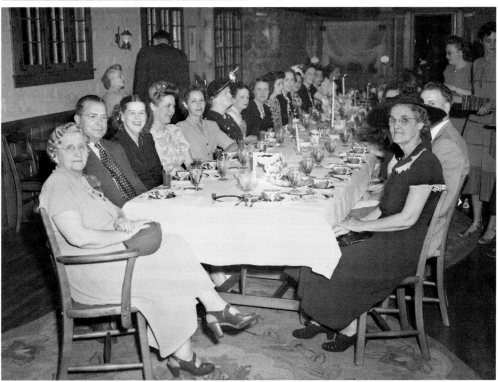

Edward Hurley
Contractor Edward Hurley passed through Sedalia in 1872 on his way to St. Louis and decided to stay. He soon accepted a contract to plaster the new Catholic church and began building his career. He supervised construction of many landmarks including the public library, Lamy factory, Lemp ice plant, and distinctive homes. From left to right are (first row) Kate, Austin, Ed, Tom, and Edward Hurley; (second row) Stella, Emmett, Etta, and Bill Hurley. (Courtesy of John Simmons.)

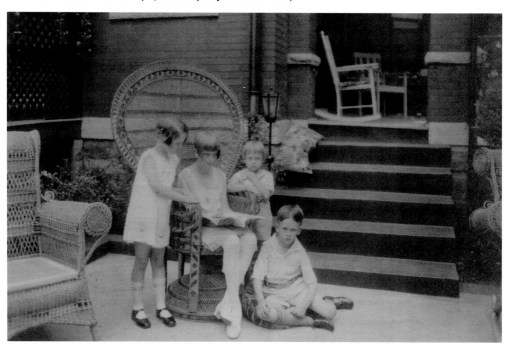

Hurley Grandchildren
In 1928, Kate Hurley hired George J. Lass to photograph four of her grandchildren on the family's new patio. History does not record if Lass brought his trained canary to capture the children's interest. However, Nell Hurley wrote, "When everything was just as he wanted it, he disappeared under a black cloth over the camera and snapped a series of photos." Pictured from left to right are Nell, Tatty, Ebb, and Tom Hurley. (Courtesy of John Simmons.)

CHAPTER TWO

Education and Inspiration

When asked about the individuals who most greatly influenced their lives, many people name a teacher or minister. Schools and churches were among Sedalia's first priorities, and the two were closely linked. "It is by true education that the moral responsibilities of the human family are better understood," the *History of Pettis County, Missouri* noted in its section about early schools. It continued, "The more education, the better the Christian." Sedalia's church roots date to 1861, when Elder George W. Longan preached the first sermon ever delivered in Sedalia. A small group gathered near the present Amtrak depot, many having been part of the Christian church in Georgetown. That worship service marked the beginning of Sedalia's First Christian Church. It was soon followed by other denominations, including Catholic, Methodist, Baptist, Episcopal, and Presbyterian. Sedalia's school system began shortly after the Civil War, when several people requested an election to adopt a free school. The school concept was approved, and the Broadway School was completed in 1868. This chapter honors those who have dedicated their lives to helping people grow educationally and spiritually.

Eva Griffin
When Broadway School opened in 1868, Eva Griffin was ready to greet her students. She was paid $60 per month, out of which she purchased supplies. As a woman faculty member, she subscribed to the Sedalia school board's stance on remaining single. The board passed a resolution toward women teachers in 1892, cautioning them about the "folly of matrimony." The *Sedalia Democrat* reported that the action was a "forewarning to the ladies that, in the wisdom of the gentlemen comprising the board who are, by the way, men of experience, the step will incapacitate them for trainers for the young idea."

Dr. C.F. Scotten

Dr. Clyde Foster Scotten served as county superintendent of Pettis County schools from 1927 to 1967. He faced the immense task of overseeing work at more than 100 rural schools. Many graduates of one-room schools still remember his visits, as well as the influence of his wife, Maude Embrey Scotten. In 1974, Dr. Scotten completed a 173-page book titled *History of the Schools of Pettis County, Missouri*. (Courtesy of Sedalia Public Library.)

Bothwell School Graduates

John Homer Bothwell provided funding for a school and teacherage near his rural lodge home in 1916. It operated until 1968, when it was consolidated with the Sedalia district. Pictured in 1950 are, from left to right, Mrs. Melvin Dexheimer (teacher), Richard Sprinkles, Jamie Greer, Rev. Henry Leimkuehler, Don Abney, Alfred Mittenberg, Dean Richards, Rev. Roy Bowers, Harry Joe Runge, Barbara Sue Wise, and Dr. Clyde F. Scotten.

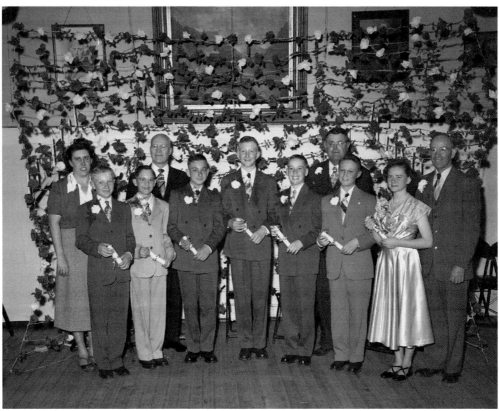

Dr. Heber U. Hunt
Dr. Heber U. Hunt moved to Sedalia in 1925 as the first principal of Smith-Cotton High School. He was superintendent of Sedalia schools from 1927 until his retirement in 1958. In 1962, a new elementary school at West Seventh Street and Warren Avenue was named in his honor.

Salome Taylor
When Salome Taylor retired from teaching at Sedalia District No. 200, she started making biannual journeys to Haiti. "My goal is to tell them about God and his son, Jesus, and pray that the Holy Spirit will move in them to live an upright life for Jesus," she says of her mission work. She also teaches hygiene classes and distributes clothing, money, Bibles, toys, and school supplies. (Courtesy of Salome Taylor.)

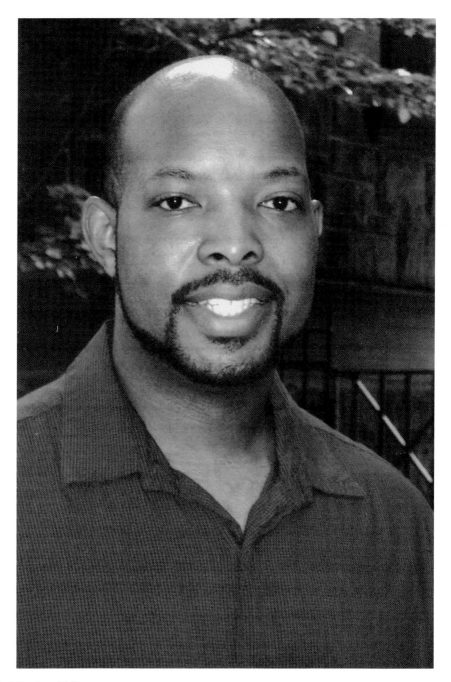

André Taylor, PhD
Dr. André Taylor, son of Salome Taylor and a 1991 Smith-Cotton graduate, received the Presidential Early Career Award for Scientists and Engineers (PECASE) in 2011. A White House press release describes the award as "the highest honor bestowed by the United States government on science and engineering professionals in the early stages of their independent research careers." Dr. Taylor is an assistant professor in the Department of Chemical and Environmental Engineering at Yale University. (Courtesy of Dr. André Taylor.)

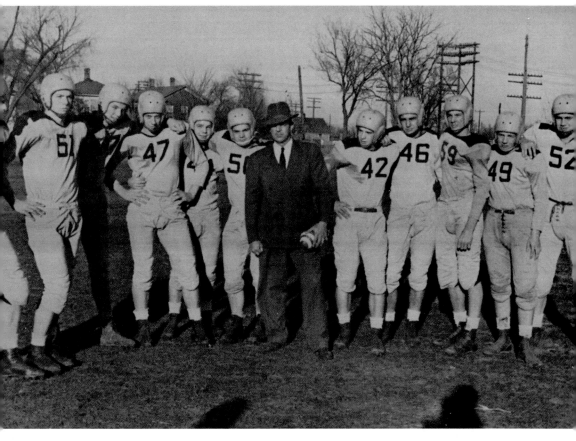

Ralph Waldo "Stub" Dow Jr.
Coach "Stub" Dow joined the Smith-Cotton High School faculty in 1941 as an assistant football coach and mathematics teacher. He served as an athletic director for the US Army during World War II and then returned to Smith-Cotton and became head football coach. When Dow died in 1962 at age 50, KDRO radio wrote a tribute that was published in the 1962 *Archives*. "As the wind whistles through the goal posts at Jennie Jaynes Stadium, look closely," the tribute noted. "See that shadowy figure with the hat and light-colored coat striding up and down the sidelines . . . As the stands go wild, you might hear that chuckle. Old 'Stub' has called the right one again." The 1952 Smith-Cotton Tigers starting lineup is pictured here. From left to right are Jim Dent, Herb Ford, Don Allcorn, Ralph "Skip" Schulz, Bill Arnold, Stan Walch, coach Stub Dow, Richard Lanning, Floyd Burton, Gene Rathburn, Wilbur Bain, and Bob England. (Courtesy of Jerry Green.)

Prof. C.C. Hubbard

While Christopher Columbus Hubbard died in 1947, his portrait continues to keep watch over the former school that bears his name. Professor Hubbard served as principal of Lincoln High School from 1906 until his death in 1947. The high school was renamed in his honor in 1943. After closing as an educational center in 1980, it was renovated as the Lincoln Hubbard Apartments in 2009. (Courtesy of Elaine Ray.)

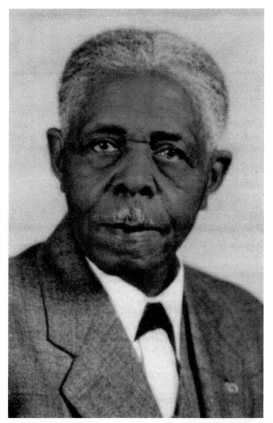

Lincoln-Hubbard Reunion

In 1980, the same year the Hubbard School building ceased to be used for education, Gloria Shephard organized the Lincoln-Hubbard Reunion Committee. The committee hosted its first reunion a year later. Reunions have been held every three years since 1985, now organized by Elaine Ray. Pictured at the registration table for the 2012 reunion are, from left to right, Belva Morney, Elaine Ray, Ronald Johnson, Dorothy Drones, and Raymond Taylor.

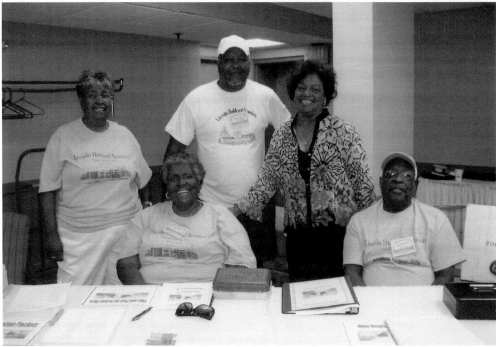

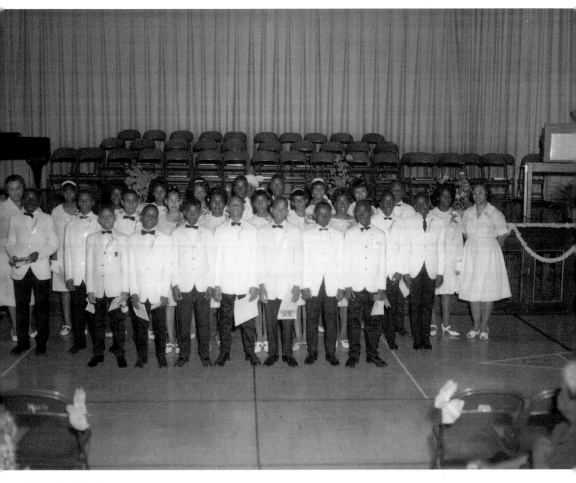

Dorothy Kitchen
Generations of Lincoln and Hubbard School students remember the care and personal touch bestowed on them by Dorothy Kitchen (right). "Mrs. Kitchen," as her students knew her, retired in 1975 after 41 years of teaching. She was principal at Lincoln Elementary School from 1957 until the school closed in 1973. She then became a homeschool coordinator for the Sedalia School district. She passed away in 2012 at age 98.

Sisters of St. Joseph
The Sisters of St. Joseph arrived in Sedalia in 1877 and began teaching at a school east of St. Vincent's church. They purchased the former home of Col. John F. Phillips at Fourth Street and Washington Avenue in 1881. There, the sisters lived and conducted a private school called St. Joseph's Academy. The house, the first brick residence erected in Sedalia, was torn down in 1944. (Courtesy of Jane Harris Yount.)

Mary Jo Welliver McMullin and the Sacred Heart Class of 1951
The future stretched before each of these Sacred Heart seniors as they observed Kid Day in 1951, celebrating childhood a final time before assuming adult responsibilities. Mary Jo Welliver (back row, seventh from left) traded caring for dolls for caring for patients when she became a registered nurse. She began her 50-year career at Bothwell Regional Care Center, then Bothwell Hospital, in 1955. She became director of nursing in 1985, a position she held until retirement in 1998. After retirement she continued to work at the hospital until 2005. Others in the class of 1955 are, from left to right (first row) David Moriarty, Catherine Bax, Charlotte Weimholt, Jean Askren, Margaret Ellen Todd, Nancy Self, Katherine Boul, Jo Ann Stohr, Jo Ann Shafer, and Mary Morley; (second row) Bernie Curry, Eddie Burke, Betty Jo Dick, Jeanette Askren, Amelia Weller, Pat White, Mary Jo Welliver, Doris Eckhoff, Agnes Westermier, Phillip Meyer, and Jim Menefee.

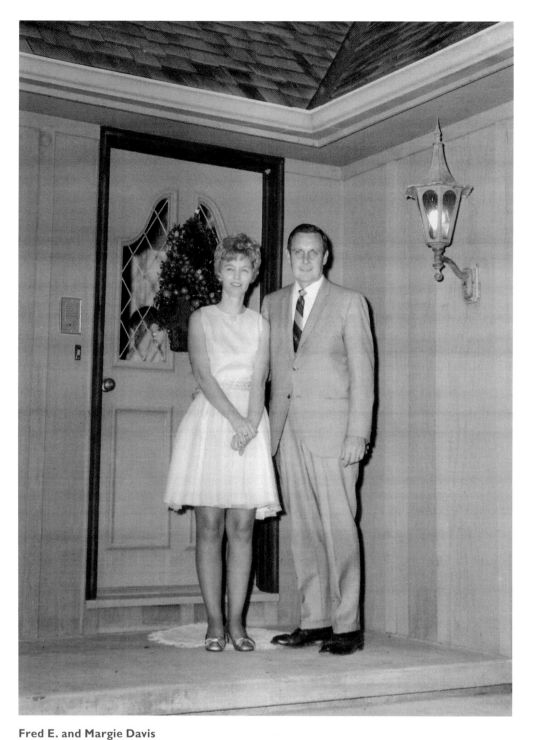

Fred E. and Margie Davis
State Fair Community College opened in September 1968 with Fred Davis in place as its first president. Pictured with his wife, Margie, Davis served as president until his retirement in 1984. Known for their warmth and hospitality, the Davises frequently opened their home to college functions.

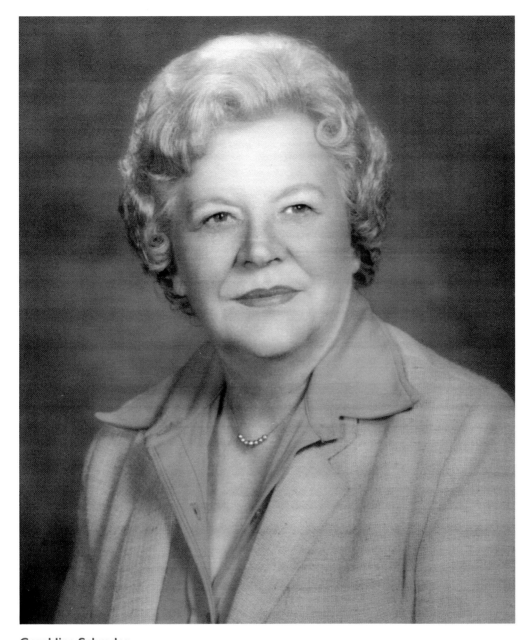

Geraldine Schrader
Geraldine Teufel Schrader instilled a love of music in generations of Sedalians. She taught at Mark Twain and Horace Mann Elementary Schools and directed orchestra, band, and choir at Smith-Cotton High School. From 1969 until her retirement in 1981, she taught music at State Fair Community College and was chairwoman of the Fine Arts Department. She was the first woman elected to the State Fair Community College board of trustees. Active in the arts, Schrader directed several productions for the Sedalia Community Theatre and received the STAR Award from the Liberty Center Association for the Arts in 1999. She also started the annual Christmas presentation of Handel's *Messiah*. When she died at age 89 in 2004, her obituary stated: "Her influence as a music educator was seen in the number of students who became professional musicians and teachers." (Courtesy of Barbara Schrader.)

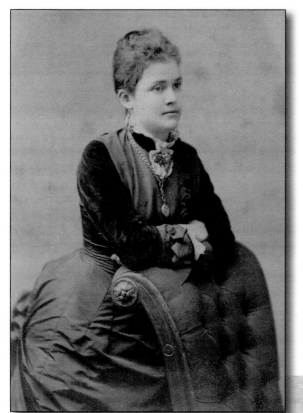

Jennie Jaynes Lewis
While Sedalia sports fans might not recognize the woman in this vintage photograph, they will know her name. Jennie Jaynes Lewis was a daughter of Col. A.D. Jaynes, who settled in Sedalia in the 1860s. Her will recommended that trustees use part of her estate to establish a recreational center for Sedalia. The Jennie Jaynes Stadium was dedicated in 1953 and has since hosted Tigers football games and community events. (Courtesy of Bothwell Lodge State Historic Site, Missouri State Parks.)

May Hawkins Ilgenfritz
Education was primary among May Hawkins Ilgenfritz's philanthropic pursuits. Her estate continues to provide scholarships for Pettis County students. She also left bequests to Bothwell Hospital, providing equipment such as an iron lung in 1949. She married Lyndol "Lynn" Ilgenfritz, who operated his family's hardware store in downtown Sedalia. May Ilgenfritz died in 1941. (Courtesy of Lewis P. Andrews III.)

Elizabeth Yeater
When her husband, Charles E. Yeater, died in 1943, Elizabeth Doyle Hawkins Yeater made certain his name lived on. After her own passing, she left $2.3 million to State Fair Community College. Funds produced the first permanent building on the college campus, now known as the Charles E. Yeater Learning Center, which opened in 1976. A Sedalia attorney, Yeater was appointed vice governor of the Philippines by Pres. Woodrow Wilson. (Bothwell Lodge State Historic Site, Missouri State Parks.)

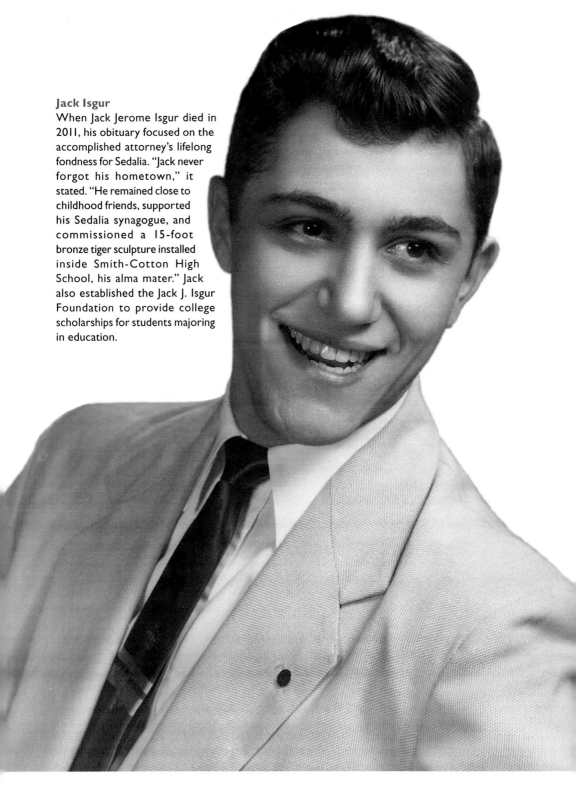

Jack Isgur
When Jack Jerome Isgur died in 2011, his obituary focused on the accomplished attorney's lifelong fondness for Sedalia. "Jack never forgot his hometown," it stated. "He remained close to childhood friends, supported his Sedalia synagogue, and commissioned a 15-foot bronze tiger sculpture installed inside Smith-Cotton High School, his alma mater." Jack also established the Jack J. Isgur Foundation to provide college scholarships for students majoring in education.

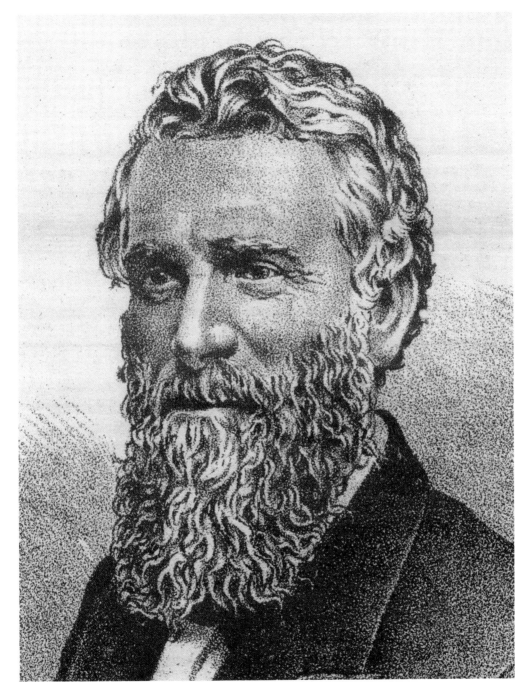

The Reverend E.T. Brown
In 1865, the Reverend E.T. Brown arrived in Sedalia as a missionary and organized the First Baptist Church. Realizing Sedalia's potential to attract railroad workers, he subdivided his 40-acre farm into East Sedalia. He exhausted his own cash on the venture, often advancing workers funds to build homes. His wife then opened their residence to boarders and raised $3,000 to build East Sedalia Baptist Church. He served as its pastor for three years without pay.

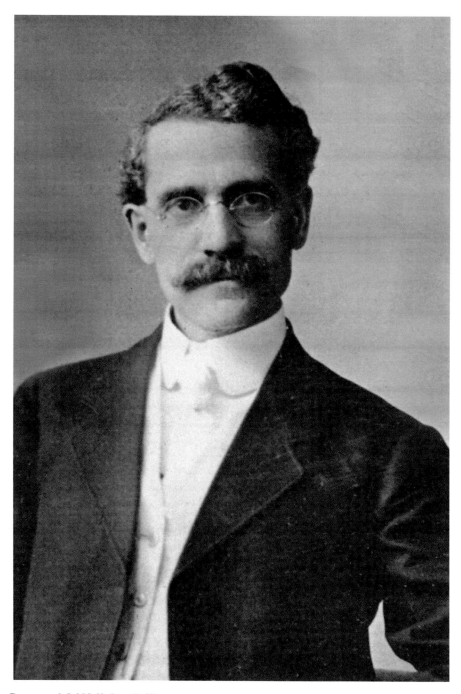

The Reverend A.W. Kokendoffer
When the Reverend A.W. Kokendoffer retired in 1943, the *Sedalia Democrat* reported he rarely used notes and never had repeated a sermon in more than 50 years of preaching. He became pastor of the First Christian Church in 1908 and performed more than 3,000 weddings in Sedalia, many at his home. Rev. Kokendoffer and his wife, Laura Gentry Kokendoffer, remained in Sedalia after retirement, where he died at age 95 in 1956.

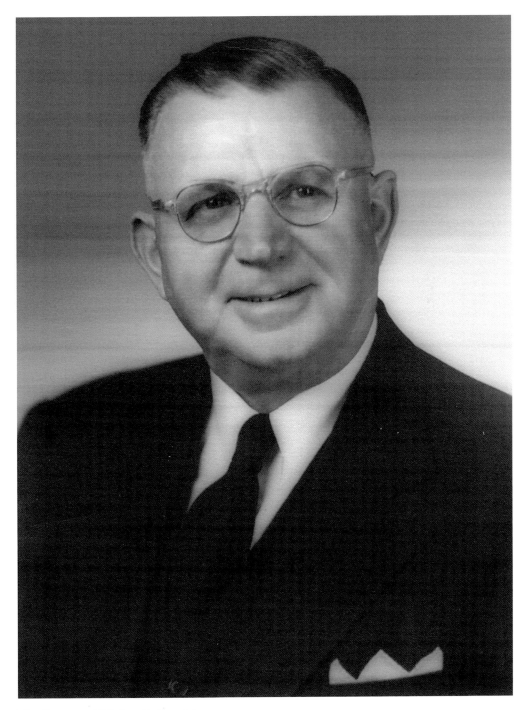

The Reverend Walter P. Arnold
In 1951, while pastor of the East Sedalia Baptist Church, the Reverend Walter P. Arnold officiated at 40 weddings—more than twice the number of any minister in Pettis County. No wonder he was known as the "Marryin' Parson"! He pastored nine Baptist churches in 57 years and later served as secretary of the Missouri Baptist Brotherhood in Jefferson City. He retired to Sedalia, where he passed away in 1971.

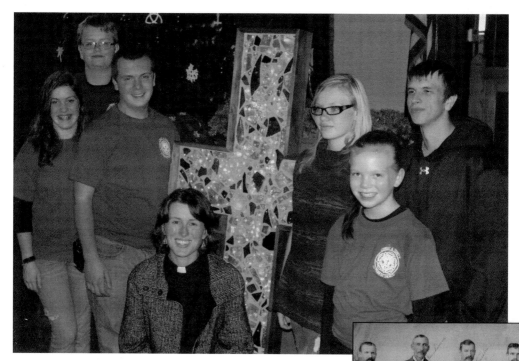

Christ & Trinity Lutheran Church

At right, top, in 1894, the Cross of Christ formed the foundation for Trinity Evangelical Lutheran Church, founded by, from left to right, (first row) Dr. A.F. Dresel, Rev. John F. Seibert, and Carl Frederick Lueking; (second row) J.H. Meyer, A. Dexheimer, J.G. Gieschen, and H.H. Kroencke. The cross symbolizes the continuing ministry of the congregation, which consolidated with Christ Lutheran Church in 1960. Above, on November 27, 2011, the youth group from Christ & Trinity Lutheran Church presented the congregation of Peace Lutheran Church in Joplin with an illuminated cross the youth made from broken glass they found at the site of Peace Lutheran's building, which was destroyed in the May 25, 2011, tornado. Pictured from left to right are Meaghan Mueller, Chaz Satnan, Alex Eppenhauer, Pastor Knowle-Zeller, Emily Greble, Allison Eppenhauer, and Mitch Morenz. Not pictured is Caitlyn Craig. Hannah Satnan, shown at right bottom, instigated the project. "The youth know that they have been claimed and called and sent to be God's hands and feet in the world," wrote Christ & Trinity pastor Kimberly Knowle-Zeller in the *Sedalia Democrat*. "The cross shines in them—a cross that leads from pieces of stained glass and wreckage to pieces of hope." (Photographs courtesy of Jane Harris Yount, Bob Satnan/ the *Sedalia Democrat*.)

CHAPTER THREE

Businesses and Services

The earliest known photograph of Sedalia shows rows of uneven frame buildings flanking both sides of East Main Street. This was Sedalia's business district in 1868. During this era, each business owner built a wooden plank sidewalk in front of his store to protect pedestrians from the dusty or muddy streets. The sidewalks became a bigger hazard than the streets, however, as they were built of varying heights. People were cautioned to "look well with eyes and lanterns of night" lest they trip when the sidewalk levels abruptly changed. The business owners in that 1868 photograph did not mind the primitive conditions. Some, like W.E. Bard and William Bloess, had moved to Sedalia before the Civil War and had watched their shopping district become a battleground. They knew what it was like to see bodies piled in the streets. Other business owners had moved to Sedalia after the war, when the town was seen as a place filled with opportunity. Sedalia's first businesses represented the necessary services for a new town: general stores, druggists, lumber and hardware dealers, grain stores, and agricultural support stores. As the town grew, so did the variety of businesses. Jewelers, clothiers, milliners, and haberdashers provided a touch of elegance for the "Queen City of the Prairies." As Sedalia entered the 1900s, a new generation of businessmen brought their influence to the city. Elliot M. Stafford, J.R. Van Dyne, Guy Snyder, E.W. Thompson, W.E. Bingaman, Julian Bagby, and William R. Parkhurst helped the town reach new heights. This chapter provides a chronological look at the development of a portion of Sedalia businesses.

W.E. Bard Jr.
W.E. Bard Jr.'s father founded the W.E.
Bard Drug Company in 1860. Young
Bard began to work in the store as
a child. By age 10, he was said to be
as knowledgeable as any adult clerk.
He contracted typhoid fever while on
vacation and died in Naples, Italy, in 1930.
His wife, Mazie, also became ill and died
eight days after her husband, without
knowing of his death. (Courtesy of Sedalia
Public Library.)

Leo Bloess
Three Bloess brothers—Theo, Otto,
and William—came to Sedalia in 1860.
They engaged in the lumber business,
with William operating Bloess Lumber
from the end of the Civil War through
his death in 1880. It then became Gallie
Lumber. Otto's son Leo and Lee Looney
bought it back from Gallie around 1904.
The Bloess family operated the Looney
and Bloess Lumber Company until 2008.
(Courtesy of Tom Bloess.)

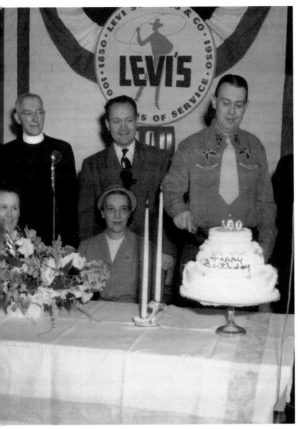

The J.A. Lamy Manufacturing Company

In 1866, Ernest Lamy opened a tailoring and haberdashery business on West Main Street that grew into the J.A. Lamy Manufacturing Company. Elliot M. Stafford Sr. acquired the business in 1912. The Stafford family led the J.A. Lamy Manufacturing Company in celebrating the 100th anniversary of Levi Straus in 1950. Pictured are, from left to right (first row) Vinnie Denny and Virginia Stafford; (back row) Rev. Fr. Andrew Brunswick, Rev. Warren Neal, and Elliot M. Stafford Jr. The Swearingen family continued the Staffords' tradition of company ownership and community involvement. H.W. Swearingen joined Lamy's as vice president in 1973 and became president in 1991. Virginia "Ginger" Stafford Swearingen, daughter of E.M. Stafford Jr., served as president of the board. Their sons Stafford and John Swearingen are carrying on the family tradition. Elliot Management Services is now located in the J.A. Lamy building (below). (Courtesy of H.W. Swearingen.)

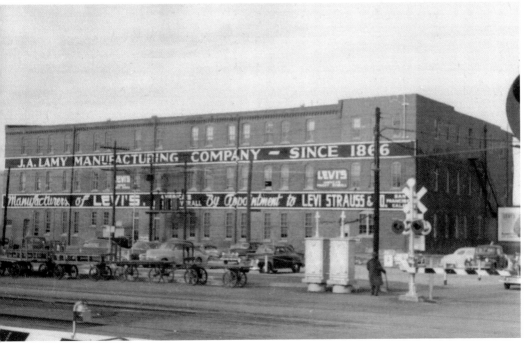

William S. Mackey
William S. Mackey joined the California Gold Rush in 1849, finding his glitter among the town's merchants rather than miners. He moved to Sedalia in 1867 and opened a shoe store on East Main Street. He later founded the Mackey Shoe Company. Mackey retired in 1889 following a paralytic stroke, leaving his sons William B. and George to carry on the business. (Courtesy of Lewis P. Andrews III.)

Charles L. Keck
From arriving in Sedalia with only $4 in 1867, Charles Keck became one of the city's most successful businessmen. He worked for the Sedalia Brewery before opening his own saloon in the 1870s. He also was engaged in a furniture manufactory and the undertaking business. Keck later opened a saloon at the southwest corner of Third Street and Engineer Avenue with his son Oscar. He is pictured with his wife, Clara. (Courtesy of James Keck.)

Bettie Gentry

Bettie Hughes married Reuben Gentry, one of Pettis County's most successful stockbreeders and traders, in 1871. When she was widowed in 1881, she assumed management of their $8,000 mansion and 1,700-acre estate. Known as a "prime favorite in the community with both young and old," she was recognized for her willingness to assist any of her neighbors, any hour of the day, with financial or medical needs. Bettie Gentry died in 1914. (Courtesy of Tom Taylor and the Alexander Majors House Museum, Kansas City.)

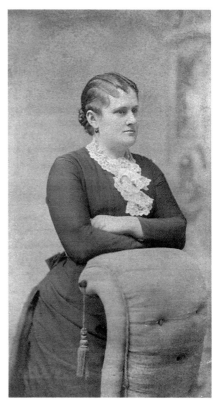

Philip Pfeiffer and Hugo Sparn

Known as businessmen for 11 months of the year, Philip Pfeiffer and Hugo Sparn took on new identities in December. Pfeiffer left Pfeiffer's Flower Shop, founded by his ancestors in 1875, to distribute fruit and candy in downtown Sedalia. Sparn turned from his Prudential Insurance career to ensuring happy holidays by acting as Santa Claus.

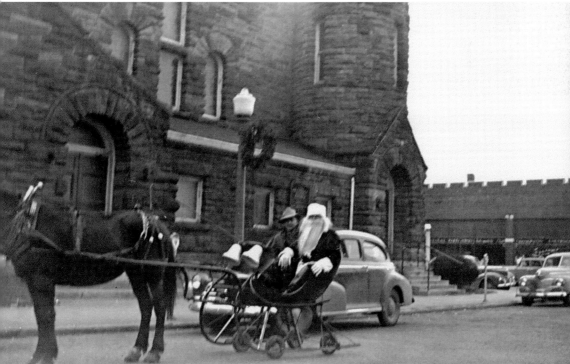

Edward G. Cassidy and Family
After arriving from Ireland in the 1870s, E.G. Cassidy became a distributor for the W.J. Lemp Brewing Company. He erected the Cassidy Block and Katy Building on South Ohio, as well as the Lemp-Sedalia Cold Storage ice factory on West Main. His own home at 706 West Fifth was a showplace, built in the mid-1890s at a cost of $20,000. He is pictured with his wife Kate (Kitty Riley) and grandson John Joseph McGrath. (Courtesy of Pam McGrath.)

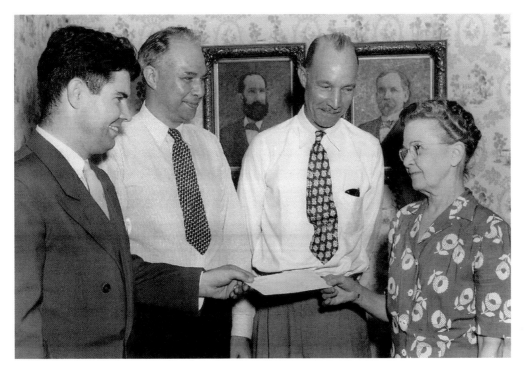

McLaughlin Brothers Funeral Chapel
John C. and George McLaughlin (portraits in background) founded the McLaughlin Brothers Funeral Chapel in 1880. They moved to its present location in the 500 block of South Ohio Avenue in 1890. Pictured in the 1950s are, from left to right, John Zander, chamber of commerce; Philip McLaughlin; Jack McLaughlin; and Della Hayes, McLaughlin Funeral Chapel receptionist. Jason and Bethany Weiker of Slater, Missouri, purchased the McLaughlin Funeral Chapel in 2009. (Courtesy of Mary McLaughlin.)

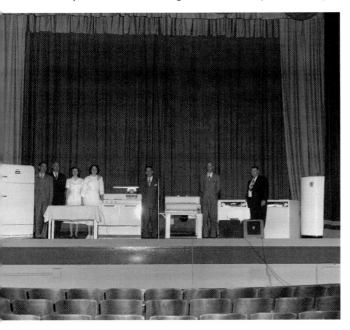

McLaughlin Brothers Furniture Store
When World War II ended, the McLaughlin Brothers Furniture Company received Sedalia's first postwar shipment of civilian appliances. The McLaughlins served their country as well as community during the war. Maj. Gen. John C. "Jack" McLaughlin III, (second from left) was on the European battlefields. Philip McLaughlin (third from right) was chairman of the Pettis County Chapter of the American Red Cross. The furniture company closed in 2010. In 2011, the McLaughlin family transferred ownership of the building to the State Fair Community College.

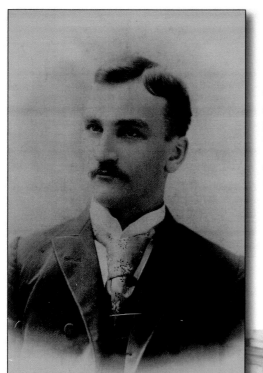

Harvey F. Keens
Harvey F. Keens began working for the Kelk Carriage Works in 1889 and became owner in 1906. Thomas Kelk had founded the manufacturing firm in 1868. Its showroom windows on Osage Avenue always displayed a new carriage, hitched to a life-size dapple gray wooden horse. The factory made its last buggy in 1923 for a physician who traveled rural roads impassable by the new "machines" that eventually made carriages obsolete. (Courtesy of Leon Keens.)

John B. Housel
While moving his family from Nebraska to Alabama in 1895, John B. Housel (seated, left) passed through Sedalia. The family liked what they saw and decided to stay. He served eight years as second ward alderman for the city of Sedalia. In 1947, the former Coal Chute Baseball Grounds were named J.B. Housel Park in honor of his civic contributions, especially pouring concrete sidewalks in northeast Sedalia. (Courtesy of Marie Housel Dabner.)

Ruth Ann Archias
Ruth Ann Archias, the youngest child of L.H. and Lula Archias, often posed in advertisements for her family's flowers. L.H. Archias established the Archias Seed Store in Sedalia in 1899 and expanded to the floral business in 1910. Active in the Sedalia community, Archias helped found the Florists Telegraph Delivery Association and Missouri State Florists' Association. The Archias Seed Store remained a Sedalia landmark until closing in the mid-1990s. (Courtesy of Leon Keens.)

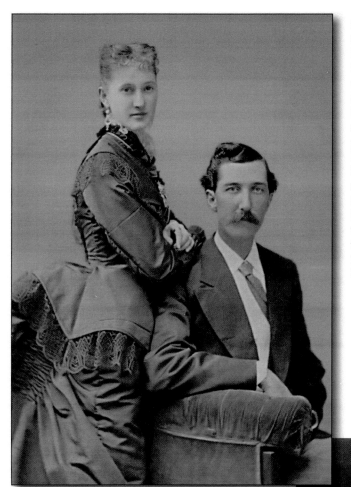

Henry Wilson and Leona Boggs Harris
For nearly a century, the Harris name was synonymous with Third National Bank. Four members of the Harris family—father, son, grandson, and cousin—served as bank presidents. Henry Wilson Harris was named president in 1901, a position he held until he retired in 1921 to become chairman of the board. He is pictured with his wife, Leona Boggs Harris, on their wedding trip to St. Louis in 1875. (Courtesy of Jane Harris Yount.)

H.W. and Janet Quinn Harris
Third-generation H.W. Harris became president of Third National Bank after his father's death in 1961. Born in Sedalia in 1929, H.W. Harris graduated from Smith-Cotton High School in 1947. He earned a degree in business administration from the University of Missouri–Columbia and also graduated from the Wisconsin University Graduate School of Banking. He is pictured with wife, Janet Quinn Harris, and sons Quinn (left) and Wade in 1973. (Courtesy of Jane Harris Yount.)

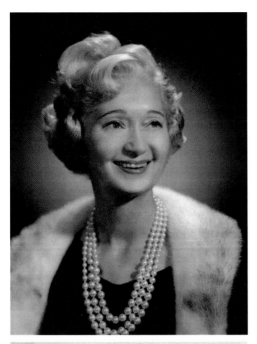

Virginia Flower

Virginia Flower moved to Sedalia in 1904 at age five. Her father owned the C.W. Flower Company, a department store that Virginia managed after her parents' death. Sedalians hold fond memories of the store's tearoom, fashion shows, and pneumatic tube payment system. Virginia Flower died in 1967, leaving a $170,000 bequest and $90,000 grant that enabled a new facility for the Children's Therapy Center to be constructed near Bothwell Hospital in 1973. (Courtesy of the Pettis County Historical Society.)

CONSTANT PROGRESS SINCE 1908

J. R. VanDyne founded the American Disinfecting Company late in the year 1908, and was the originator of Soluble Pine Disinfectant. ADCO remained under his progressive supervision until November, 1916. His creative ability is the foundation on which a true service institution has been built.

J. R. VAN DYNE, SR., Founder

C. D. VanDyne took over the active management of ADCO after the passing of his father and continued the company's expansion until his death on March 22, 1930. The company's steady progress and its modern facilities stand as a memorial to this progressive father and son.

C. D. VAN DYNE

The three remaining sons of Mr. J. R. VanDyne, Sr., namely, Chas. M. VanDyne, John R. VanDyne, Jr., and V. D. VanDyne, devote their full time to the affairs of The American Disinfecting Co.

The Van Dynes and Adco

J.R. Van Dyne and his wife, Vivia D., founded the American Disinfecting Company in 1908. The company changed its name to Adco in 1944. It eventually occupied several buildings on West Main Street, where it manufactured cleaning chemicals and products. In 2007, the Van Dyne family sold the company to Mentor Partners of Cambridge, Massachusetts. Adco was sold again in December 2011 to Equinox Chemicals of Albany, Georgia. Adco no longer exists in Sedalia.

Florence Middleton Thomas
When Florence Thomas had a "rat" problem, it meant she was rolling a woman's long hair around a device by that name. She opened Sedalia's first beauty salon on Ohio Avenue in 1911. Her business grew from 10 customers per day to nearly 100, employing six operators and one apprentice. (Courtesy of Sedalia Public Library.)

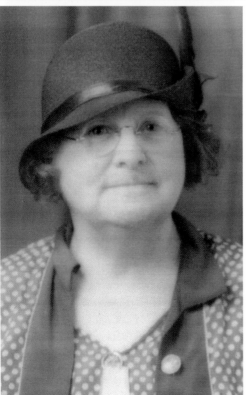

Minnie Dubbs Snyder
Cornelius and Minnie Dubbs Snyder opened Snyder's Confectionery in 1913. Cornelius ran the restaurant, while Minnie traveled as a district manager for the Yeoman Income Insurance Company. When Cornelius died in 1935, Minnie took over the restaurant and made it a profitable venture in an era when bankruptcy was as common as ice cream in a chocolate sundae. After retirement, Minnie worked for her youngest son, Guy, who founded Inter-State Studio in 1933. (Courtesy of Tim and Christie Curry.)

Guilvardo Flores Sr.

Mexican-born Guilvardo Flores followed his brother, Rodolfo, to Sedalia in 1921, where both attended the Sedalia Business College. Guilvardo purchased Fisher Printing Company in 1932. In 1942, he also purchased part of Artistic Printing, becoming a partner with Herbert Liming and consolidating the two businesses. Later, Flores bought out Liming, becoming sole owner. Flores then named the company Ideal Printing and operated it until the day he died in 1963. (Courtesy of Lisa Flores.)

George and Despina Berbatis

While the Coney Island Lunch Room at 110 South Ohio Avenue was small in size, it was big on memories. The signature Coney Island sandwich consisted of a piece of rolled meat in a bun. Berbatis (center) operated Coney Island from the 1920s to the 1950s. He and his wife Despina passed away in 1976 and 1986. They are pictured with Tom Berbatis in 1947.

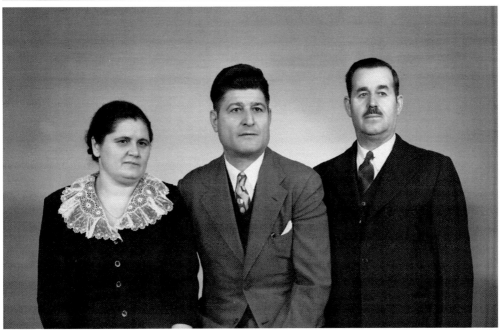

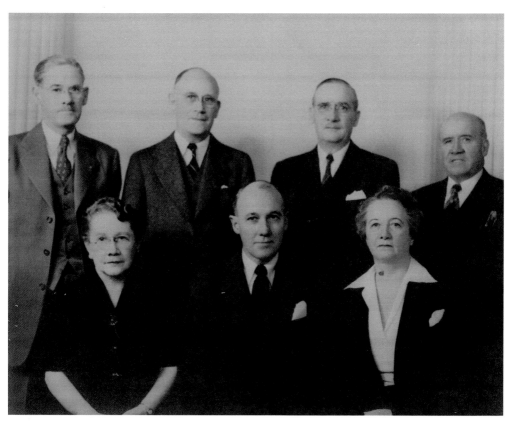

The Hurley Family

Austin Hurley purchased part of Queen City Electric in 1910; his brother Thomas A. Hurley acquired the remainder after World War I. Thomas A. Hurley's son Tom began working for Queen City as a teenager. His sons Jack, Dan, and Mike later joined the business. The company was located at 317 South Ohio Avenue from 1926 until closing in 2012. Pictured are, from left to right, (first row) Etta, Austin, and Stella; (second row) Bill, Tom, Emmett, and Ed Hurley. (Courtesy of John Simmons.)

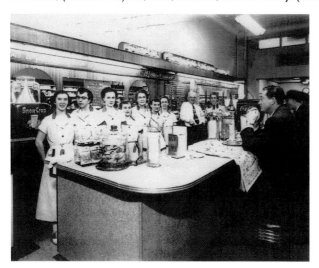

Howard Robinson

In 1916, Howard Robinson (standing behind the fountain at the Sedalia Drug Company) began his career with Wilcox and McFarland Drugs. He later owned McFarland and Robinson Drugs and the Sedalia Drug Company. Robinson built the Del Rey, Del Mar, and Ruby Lea Apartments on South Ohio Avenue and a distinctive home at 700 South Carr Avenue. He built Christmas displays for his front yard that created traffic jams each holiday season. (Courtesy of Jack McMurdo and James Keck.)

Robert W. Mason
In 1915, two years after the Union Savings Bank was chartered, Herbert W. Mason started working at the bank as a teller and janitor. The Mason family acquired controlling interest in the 1930s, and Herbert Mason became president. He remained involved in the bank until his death in 1983. His son Robert W. Mason became president upon his father's death and remained in that office, working daily at the bank, until his death in 2010. Robert Mason's son Mark followed him as president. Mark Mason died in 2011. Other family members worked in the bank, serving the financial needs of the community over the years. After the deaths of Robert and Mark Mason, in accordance with their wishes, the board of directors of the bank merged with Third National Bank of Sedalia. The Mason legacy lives on through generous bequests to the Center for Human Services and State Fair Community College Foundation. (Courtesy of John S. Berry.)

John Homer Bothwell

People often envision John Bothwell as a staid, stern, and straight-laced attorney. They have a way of doing that with historic figures, especially those who become public benefactors. But Bothwell, known as "Homer" to his friends, was the life of the party. This dashing bachelor and member of the Amity Dancing Club married Hattie Jaynes in 1884. After her death in 1887, Bothwell remained a widower for the rest of his life. He generously gave back to his community, providing funds for a school, hotel, and hospital. In 1896, he began building a rustic cottage on a rocky bluff north of Sedalia. This eventually grew to a 30-room castle-like structure known as Bothwell's Lodge. The lodge became property of the state of Missouri after Bothwell's death. The Missouri Department of Natural Resources now operates it as Bothwell Lodge State Historic site.

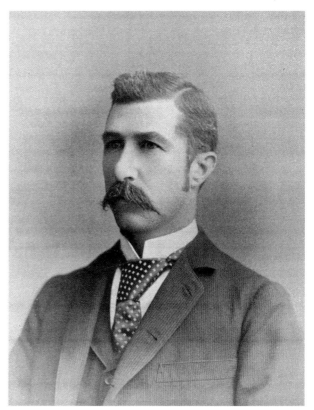

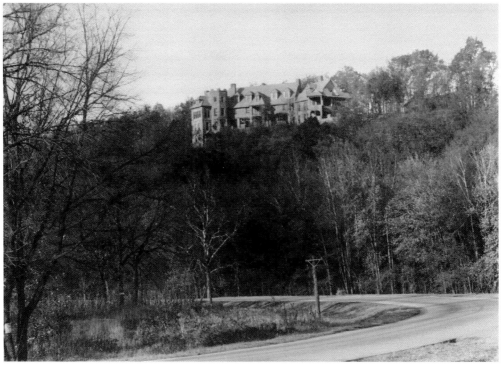

John McGrath

In 1932, after the Depression-closure of three downtown banks, John McGrath founded the Sedalia Bank & Trust Company in the building vacated by the failed Sedalia National Bank. Sedalia Bank & Trust moved to a new building at 111 West Third Street in 1948. McGrath served as president from its founding until his death in 1950. After his death, his son John J. McGrath became president. (Courtesy of Pam McGrath.)

Gus

While not an official employee of the Sedalia Bank & Trust Company, Gus was its unofficial mascot. The St. Bernard, who belonged to bank vice president Jack Kneist, mingled among downtown shoppers and rested outside the bank. Gus donned a red heart one Valentine's Day with the inscription "Thank you for banking with us." When he died in 1961, his newspaper tribute was longer than many human obituaries.

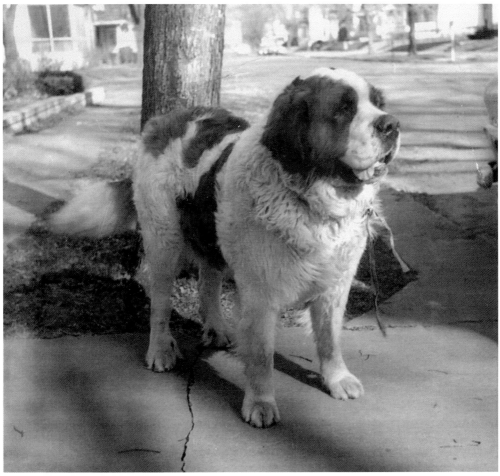

Guy Snyder

Guy Snyder, pictured with his daughter Aileen, built his traveling photography business during the Depression by looking at shoes. If children's shoes were in good shape, he found their parents would want pictures of them, so he set up his portable studio. Inter-State Studio, the company he founded in 1933, is now North America's largest family-owned school photography and yearbook publishing company, still owned by the Snyder family. (Courtesy of Aric Snyder and Inter-State Studio.)

Gerald Cecil

In 1936, at age 14 and with a 35¢ brake repair, Gerald Cecil launched Cecil's Bicycle Shop, which eventually operated from four buildings in the 700 block of South Ohio Avenue. He expanded into radios and televisions and introduced Sedalia's first television set in 1949. People stood for hours outside his store, watching a television's six-inch screen in his display window, even when it showed nothing but test patterns. He was proud to provide a livelihood for those who worked for him over the years. (Courtesy of Gerald Cecil.)

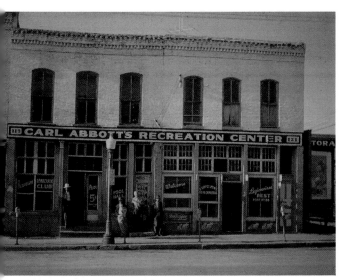

Carl Abbott

Carl Abbott operated his recreation center at 119–121 East Main Street. He was president of the Negro Welfare Society and founded the Progressive Democratic Club in 1933, which was headquartered in his building. The same building housed the Maple Leaf Club, a social organization for black men, where a pianist named Scott Joplin once tickled the ivories. The building was torn down in 1958; Maple Leaf Park now occupies the site. (Courtesy of Jane Harris Yount.)

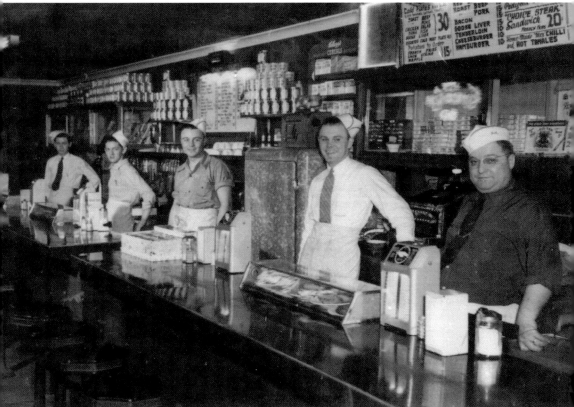

Pete's Pig Pen

Pete Drenas opened Pete's Pig Pen at 420 South Osage Avenue in 1934. Kenneth "Duke" Stivers bought half interest in the restaurant after World War II. He became full owner in 1953. Pictured from left to right are Pete Drenas, Kenneth "Duke" Stivers, Jim Stivers, Jack McMurdo, and Elroy Deepler. (Courtesy of Jack McMurdo.)

Duane and Beulah Ewing
Duane and Beulah Ewing (above) moved to Sedalia from Kansas City in 1935. They founded Ewing Funeral Home in the former home of James Glass, 701 South Osage Avenue. Duane Ewing retired in 1981 and died in 1987, leaving community bequests that keep the Ewing name alive. The funeral home now is known as the Ewing-Schutte-Semler Funeral Home. (Photographs courtesy of Ewing-Schutte-Semler Funeral Home.)

Julian Bagby
Ice cream and soda pop sound like a dream combination. They were for Julian Bagby. He began working for Tullis Hall Ice Cream in 1920 and managed the company after Beatrice Foods purchased it. He started a Pepsi-Cola franchise in 1939 and oversaw the plant's relocation after it was destroyed by fire 30 years later. Bagby, a three-term Sedalia mayor, died in 1990 at age 90.

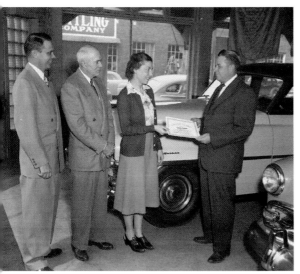

Frank Bryant and Ben Robinson
Frank Bryant (second from left) and his son-in-law Ben Robinson (left) founded Bryant Motors in 1936. They are pictured in 1952 when employee Lavonna Fischer received an award from a representative of Chrysler. Queen City Motors, shown in this photograph in its headquarters at West Second Street and South Kentucky Avenue, sold Chryslers and Plymouths across the street from Bryant Motors, which was the Dodge dealership.

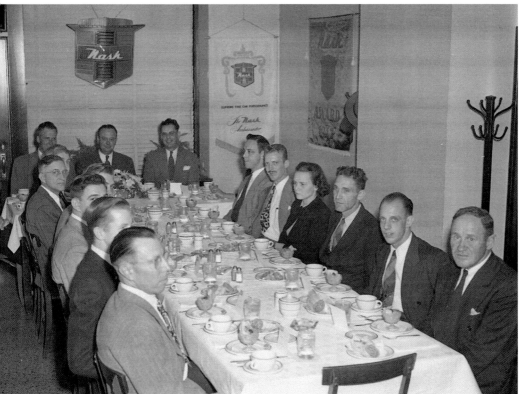

Dan Robinson
Dan Robinson (back row, second from left) began working for his brother Ben as a garage mechanic at Bryant Motors in 1937. He owned Dan Robinson Nash in the 1940s and early 1950s and purchased Bryant Motors in 1959. Bryant Motors remains Sedalia's oldest automobile dealership, sold by Dan's sons Jack and Mike to Kyle Herrick and partners in 2012. Robinson is pictured with his wife, Grace, (far left) in 1947.

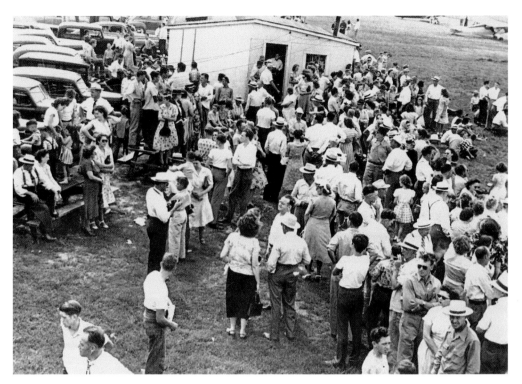

Jack Funk

Jack Funk opened his flying school west of Sedalia in 1944, offering commercial services as well as flying lessons. He also sponsored air shows, such as the one shown above in the 1940s. It featured a bombing contest in which pilots tried to hit a small building with a sack of flour. After the city of Sedalia opened a new municipal airport east of town in 1953, Funk converted his flying field to farmland.

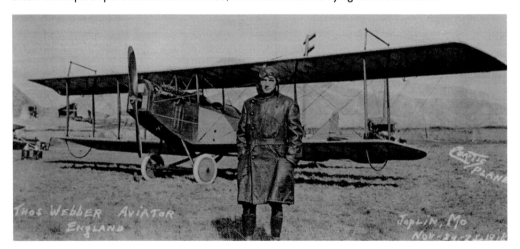

Tommy Webber

Sedalia established an airport west of city limits in 1936, located on 40 acres of leased pastureland south of Gasoline Alley. Webber, known as the "dean of airline pilots," was hired as airport manager. He also provided flying lessons. A native of England, he came to the United States after World War I. Webber retired from flying at age 72 and passed away in 1963. (Courtesy of Jack McMurdo and James Keck.)

Berry's Hatchery and Feed Company
Ivan Berry founded Berry's Hatchery and Feed Company in 1936 with 25¢ in his pocket. He also operated a 120-acre turkey farm south of Sedalia, averaging 30,000 turkeys a year. The store moved to 210 West Second Street in 1947. It became a Sedalia landmark identified by a neon sign that proclaimed, "It's the Berry's." Pictured in 1936 are, from left to right, Esther Mae, Ivan, and Karl Berry. (Courtesy of John S. Berry.)

Fanny Garst
Fanny Garst and her sisters Kathryn and Nelle Winstead opened Garst's, the first drive-in west of the Mississippi River, in 1937. She reported at 4:30 a.m. daily to prepare meat for steak burgers and bake pies. From left to right are Marjorie Garst Houk, Martin Houk, and Fannie Garst. Garst's became Eddie's in 1970, named for longtime employee and manager Eddie Boysel, and closed in 2011. (Courtesy of Carol Klein.)

Maxine Griggs

Charity auctioneers prepare for frenzied bidding when they see Maxine Griggs's name on a pie—and for good reason. She is a member of the Foodservice Hall of Fame and has been named Restaurateur of the Year by the Missouri Restaurant Association. She began her career in 1943 as an employee in the Pacific Café and also worked at the Flat Creek Inn, Old Missouri Homestead, and as manager of the Sedalia Country Club. She operated her own restaurant—Maxine's Gourmet House—at 200 Industrial Drive from 1969 to 1987, followed by the Home Place on South Highway 65, which she ran with her sister Tina. She was instrumental in founding the Sedalia chapter of the Missouri Restaurant Association and remains active in community events. She frequently donates baked goods to charity auctions and submits blue-ribbon recipes to the Missouri State Fair. (Photographs courtesy of Maxine Griggs.)

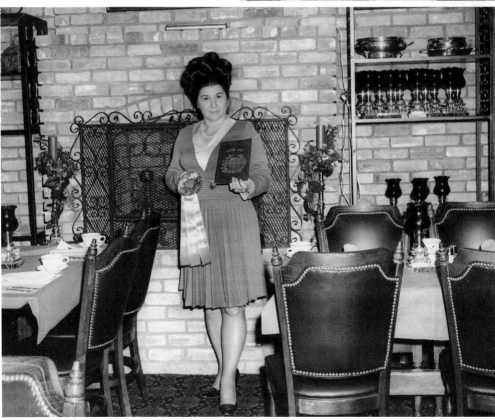

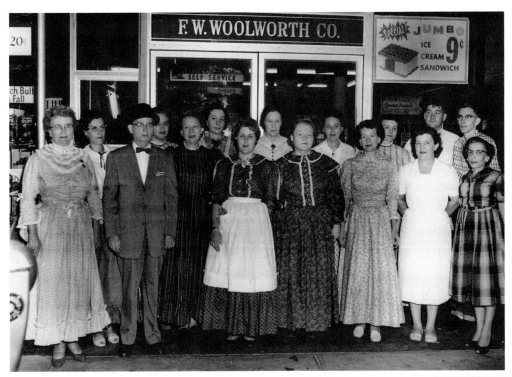

Robert Malone

World War II rationing was at its peak when Robert A. Malone became manager of the F.W. Woolworth Company. Hazel Lang, *Sedalia Democrat* reporter, never forgot his thoughtfulness. "When he would get a shipment of [nylon] hose, the first thing he would do was take out a pair or two for the reporter he knew needed them," Lang wrote. Malone (first row, second from left) is pictured with store employees in 1959. His wife, Antonia "Mamoo," placed her special stamp on the store by hand-decorating Easter eggs. She donned a bunny costume and waved from the display windows. (Courtesy of Ron Malone.)

E.G. "Ed" Kehde Jr.

Ed Kehde moved his family from Webster Groves, Missouri, to Sedalia in 1947. By 1955, he had opened his first drive-in restaurant, part of the Dog 'N Suds franchise, at 1120 South Limit Ave. The Kehdes started their own barbecue restaurant at 1915 South Limit in 1976. Ed Kehde was active in the Sedalia community, serving as a member of the school board and Rotary Club, Chamber of Commerce president, and chairman of the annual Sedalia Christmas parade. His son John and grandson Roger still operate Kehde's Barbeque, where patrons enjoy eating in a restored "Katy Flyer" train dining car. (Courtesy of the Kehde family.)

Tish Taylor
Whether chasing a live duck down Ohio Avenue or preparing to style Fan Dancer Sally Rand's wigs, excitement abounded for Tish Taylor. She opened her beauty salon in 1945 at 509 South Ohio Avenue and remained there until retiring in 1985. She then sold the business to longtime employee Margaret Schultz, who kept the salon door open—and the coffee pot on—until the building was razed in 2008. Taylor passed away in 2008 at age 90.

Lyman and Ruth Keuper
In 1947, Lyman and Ruth Keuper (right) opened the Wheel Inn Drive In at the intersection of Broadway Boulevard and South Limit Avenue. She conducted weekly training sessions for carhops. The Wheel Inn grew to national prominence, largely due to its distinctive building design and "gooberburger," a hamburger with peanut butter. When intersection expansion made it necessary to raze the building in 2007, Judy Clark reopened the Wheel Inn on South Limit. (Courtesy of Jack and Ruth Ann Hawkins.)

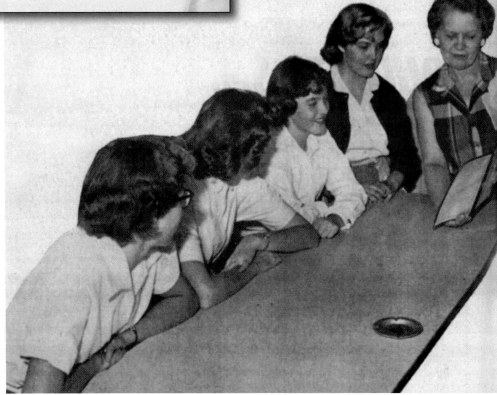

Iva Rice

From childhood, Iva Rice dreamed of opening her own restaurant. She put her aspirations on hold to teach school, rear a family, and help run Rice Leghorn Farm, the family's hatchery business (below). While driving the countryside to gather eggs from farmers, she started collecting rocks. She used her bounty to transform the swimming pool of Sedalia's former YMCA into a sunken garden–like dining room for her restaurant—the Old Missouri Homestead, which she opened in 1947. Gene Autry, Brenda Lee, Clint Eastwood, Eric Fleming, Sally Rand, and Aunt Jemima were among her patrons. She sold the Homestead in 1976 and visited it one final time, after it was destroyed by fire in 1986. Bundled up against the January cold, she picked her way through its charred rubble and picked up rocks—the same ones she had collected a half-century previously. She died a few months before her 100th birthday in 1999. (Photographs courtesy of Betty Rice Schlotter and Bobbie Rice Franklin.)

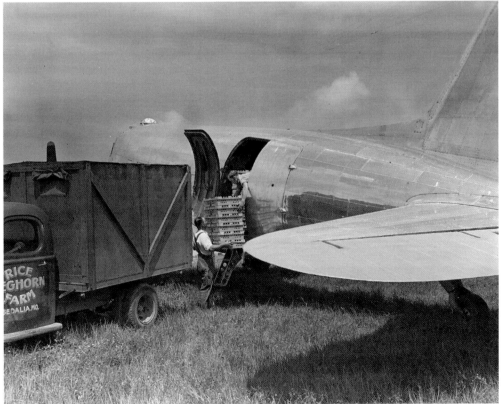

William Robert and Lucille Parkhurst
William Robert Parkhurst (left) established a manufacturing company in his name in 1946. Soon, Parkhurst Manufacturing was known across the Midwest for its quality agribusiness products. He was instrumental in establishing the first one-way system renting utility trailers. Locally, he and his wife, Lucille, are probably remembered most for their Tiki House located on an island west of Sedalia. Here, countless weddings, reunions, church picnics, and business retreats were held, all without charge. (Courtesy of Richard Parkhurst.)

Robert Richard and Judy Parkhurst
Robert Richard Parkhurst (right) worked in the family business for 30 years. In 1986, he and his wife, Judy, purchased MPI, a steel-processing center. They sold the business in 1999. Individually, they served the public with distinction and achieved many goals. They will probably be remembered most by their contributions to State Fair Community College, attested by their names posted on several venues around the campus. (Courtesy of Richard Parkhurst.)

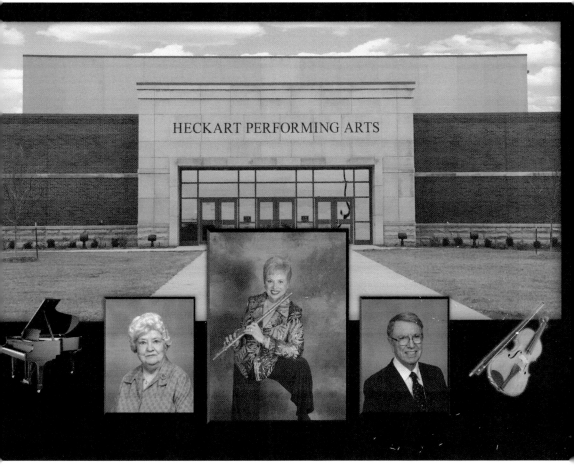

The Heckart Family
In 1948, Del and Stella Heckart and their daughter, Sue, moved to Sedalia to acquire the Gillespie Funeral Home, established in 1918. The funeral home is now known as Heckart Funeral Home & Cremation Services. Sue serves as president of the funeral home and Heckart Family Foundation, founded in 1994 to further philanthropic projects in Sedalia and surrounding communities. Recent donations include the Heckart Performing Arts Center at the Smith-Cotton High School (above) and Heckart Science and Allied Health Center at State Fair Community College. "My father came to Sedalia not knowing anyone. Over the years the community accepted my family, and we have had the honor of serving thousands of local families," Sue says. "The Heckart Family Foundation is my way of giving back to the community, not just for me, but in the memory of my mother and father." (Courtesy of Inter-State Studio.)

Hazel and Pat Clark

The Missouri State Fair not only provided entertainment, it created employment. Hazel Clark (right) was the PBX switchboard operator within the administration building. Her husband, Pat Clark (below, background), was the state-licensed sign painting vendor. He employed Leslie Hale (foreground) a gifted window-sign expert, and Jimmy Chapman (right), an exceptional portrait artist. The sign shop was located on the west side of the Coliseum building. On those hot, air condition–less August days, laughter from these three good-humored men could be consistently heard through the Coliseum's open-aired portals. They consumed gallons of iced tea from the Williams' or Bowers' cafés across the street. (Photographs courtesy of Jack Clark.)

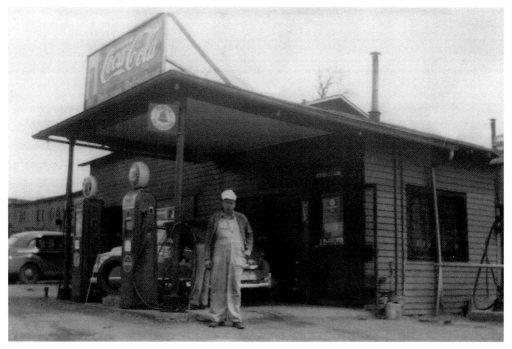

Gerald Green Sr.
W.A. Green operated the Dixcel gas station at Broadway Boulevard and Marshall Avenue. His son Gerald Green Sr. started working at the station following his graduation from Smith-Cotton High School in 1931. Gerald Green Sr. is pictured at the station shortly before selling it in 1953. His son Gerald Green Jr. now owns a near full-sized replica of a Milton Oil station in Cole Camp in honor of his heritage. (Courtesy of Gerald Green Jr.)

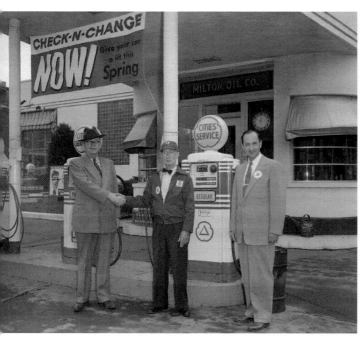

Milton Oil Employees
In 1955, Sedalia mayor Julian Bagby (left) congratulated station manager Walter Dobel outside the Cities Service station at Fifth Street and Osage Avenue. Abe Rosenthal (right), Milton Oil territory manager, took part in the festivities. Harry E. Milton founded the bulk oil company in 1912 and opened the first Milton Oil filling station in 1920. The Miltons began marketing with the Cities Service name in 1953. Cities Service bought the Milton business in 1962.

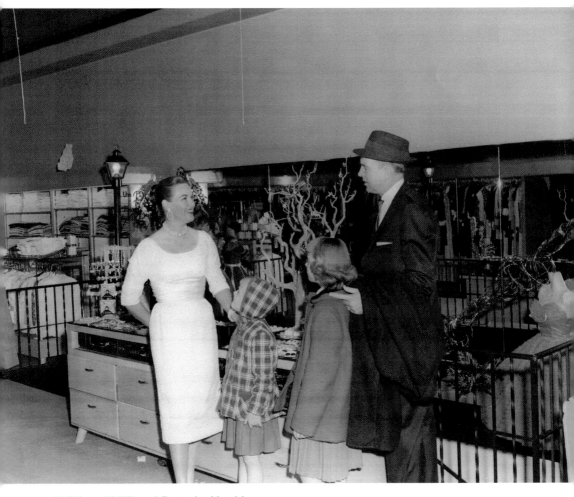

William "Bill" and Dorothy Hopkins

Always eager to support their community, Bill and Dorothy Hopkins allowed the *Sedalia Democrat* to shadow them in 1959 as they shopped in downtown Sedalia. They are pictured with daughters Jill and Cynthia in Locketts' Ladies' Shop. The Hopkins moved to Sedalia in 1953 when Hopkins, a former FBI agent, became district manager for the State Farm Insurance Company. He was active in the formation of State Fair Community College and served as president of its first board of trustees until his death in 1986. The college's student services center was named in his honor. Dorothy, an award-winning designer, used her arts talent throughout the community. She conducted interviews on Sedalia's KDRO-TV with notables such as Clint Eastwood, Dale Carnegie, Harry James, Thomas Hart Benton, and John Glenn. She also was an accomplished actress and painter. She passed away in 2010. (Courtesy of Ellen Weathers.)

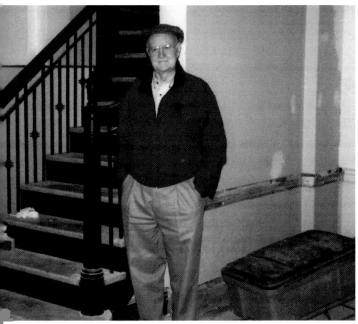

Doyle D. Furnell
In 1998, Doyle D. Furnell, chairman of family owned and operated Furnell Investments Inc., led the effort to purchase and renovate Hotel Bothwell. As a teenager, Furnell worked as a bellhop in the hotel and admired the historic property throughout his life. It was in a general state of neglect when the Furnell family took possession. With his penchant for history taking center stage, Furnell's restoration recreated the elegance of the hotel. He is pictured in 1998 when renovation efforts were underway. (Courtesy of Furnell Investments Inc.)

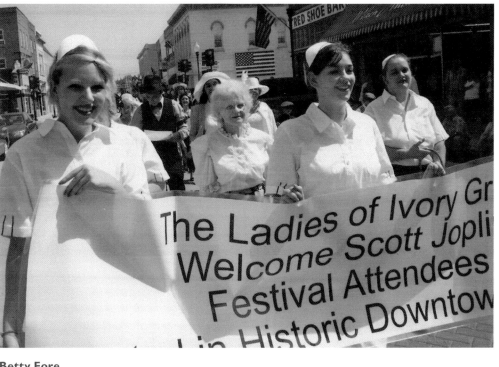

Betty Fore
When she "retired" in 2010, Betty Fore (center) became restaurant manager at the Ivory Grille in the Hotel Bothwell. She has more than 30 years' experience in Sedalia restaurants, including the Old Missouri Homestead, Sedalia Country Club, and McGrath's. She is pictured during the 2011 Scott Joplin International Ragtime Festival Parade, when Ivory Grille workers wore uniforms fashioned after a 1940s photograph. Also pictured are Abby Denham, Tiffany Oswald, and Tanya Barr. (Courtesy of Randy Kirby).

E.W. Thompson

The car-lined parking lot of Thompson Hills Shopping Center grew out of an automobile business. E.W. Thompson moved to Sedalia in 1925 and with Giles Sullivan opened the Sullivan-Thompson Chevrolet Company at 309 West Second Street. Thompson acquired the dealership that eventually occupied an entire block on West Fourth Street. He sold the Chevrolet portion to Mike O'Connor in 1951 and entered the Ford motor line, later with Bill Greer. Thompson also was a cattleman who raised purebred Angus cattle. He built Thompson Hills Shopping Center on his cattle ranch west of Sedalia in 1964, with Tempo and Katz being the first two businesses to open. Thompson passed away in 1978. The E.W. Thompson State School and the Sylvia G. Thompson Residence Center honor his and his wife's contributions to Sedalia. (Courtesy of Sylvia L. Thompson.)

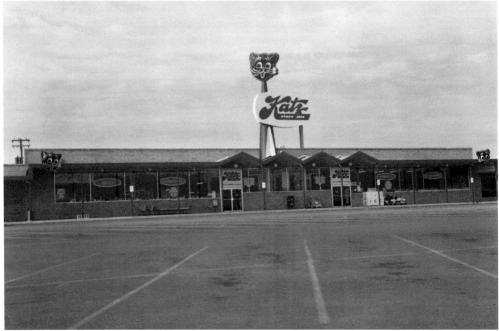

W.E. Bingaman

In 1952, W.E. Bingaman realized Sedalia needed a supermarket. Bingaman, then working for the A&P chain, poured $10,000 savings into his first store called "Bings" at Eleventh Street and South Limit. Realizing the south corridor's potential for expansion, Bingaman and several investors constructed the Holiday Inn motel in 1963. The same year, he and his son Vernon and son-in-law Morris Brown purchased 14 acres at Sixteenth Street and South Limit. They converted the former site of the State Fair Floral greenhouses into the State Fair Shopping Center, retaining the towering greenhouse smokestack as its sign. The center opened in 1965. Now operating as W.E.B. and Sons, Bingaman's descendants continue to manage the vast real estate holdings that began with a single supermarket. (Courtesy of W.E.B. and Sons.)

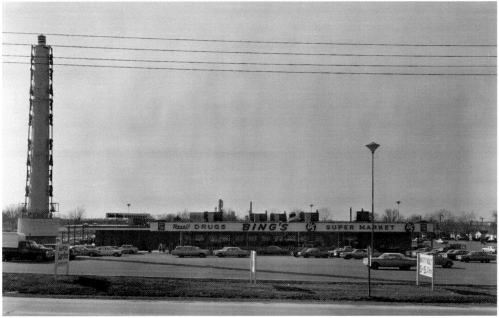

John and Bernice Ditzfeld

John and Bernice Ditzfeld founded more than a transfer company—they established a legacy of honesty, dependability, and community commitment. Ditzfeld Transfer began in 1960 with two one-ton trucks and a pickup providing local service. It now has more than 50 tractors and 100 trailers providing nationwide transit, as well as one million square feet of warehouse space. Their son Ron, now company president, credits his parents for instilling values that employees continue to live out through their business interactions. Ditzfeld Transfer is a recognized community contributor—from responding to relief efforts for local and nationwide natural disasters to supporting the Mid-Missouri Outlaws football and Sedalia Bomber baseball teams. Believing it is important to give back to the community that has given his family so much, Ron Ditzfeld established the Susie Ditzfeld Soccer Complex and supports numerous philanthropic organizations. (Courtesy of Ron Ditzfeld.)

CHAPTER FOUR

Arts and Entertainment

Sedalia's emphasis on arts and entertainment began before the city was officially founded. An agricultural and mechanical association was organized in 1857 and hosted county fairs in William Gentry's pasture. In the 1860s, after the Civil War, Sedalia's first baseball club was formed. The same decade, George R. Smith built an elaborate opera house on West Main Street. Smith's Hall, as it was known, brought in nationally-recognized speakers and entertainers. It also hosted community theater productions, school concerts, and fundraisers for local organizations. One such fundraiser in 1871 supported the formation of a "free reading room," the forerunner of Sedalia's library. The past continued to meet the present in the 1880s, when Frank and Joseph Sicher opened what the *Sedalia Democrat* heralded as "the grandest pleasure and amusement resort in central Missouri." Sicher's driving park and fairgrounds featured an amusement hall, grandstand that seated 5,000, race track, hotel, and five-acre lake. Sedalians today enjoy entertainment on these same grounds, now known as Liberty Park. In the 1890s, the tinkling of piano keys along East Main Street heralded the beginning of Sedalia's ragtime acclaim. Throughout Sedalia's history, countless individuals have furthered the city's arts and entertainment and culture. Writers, musicians, artists, actors and actresses, and athletes have shared their talents locally, nationally, and internationally. This chapter salutes the legendary locals who established the foundation for Sedalia's arts and entertainment and those who continue to keep it thriving.

Anna Dugan

Writing under the pen name "May Myrtle," Anna Dugan published a book called *Myrtle Leaves* in 1885. She was the wife of Dugan Paint founder George E. Dugan. After her husband's death, she wrote a booklet titled *The Pretenders*. The publication chronicled collecting her husband's delinquent business accounts. It featured a series of "pen portraits," the subjects of whom the *Sedalia Democrat* noted would be "readily recognized by anyone who knows the originals."

W.A. McVey and Pat Clark

History came to life when W.A. McVey (left) and Pat Clark collaborated on a television series. McVey narrated historical events while Clark painted the scenes he described. This photograph was taken in the 1970s during a KMOS-TV broadcast. At the close of the show, the paintings were auctioned off for charity. McVey wrote several books about Sedalia history, and collectors still treasure Clark's historical paintings. (Courtesy of Jack Clark.)

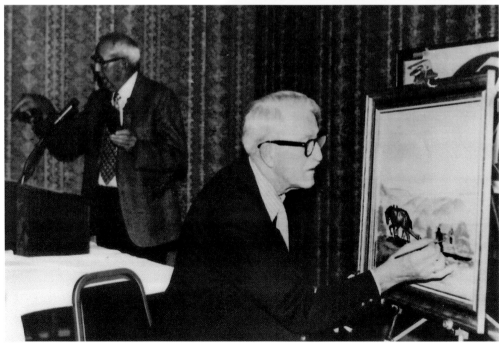

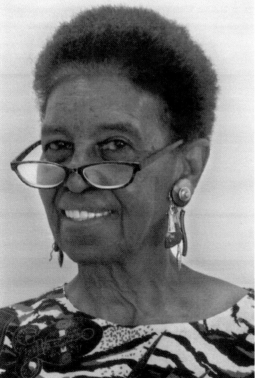

Hazel Norinne Lang

Hazel Lang began her career as a proofreader for the *Sedalia Democrat* in 1925. She became a full-time news reporter and feature writer during World War II. She is pictured above in 1969 at a book signing for her book of poems entitled *Through the Years*. After retirement in 1970, she wrote *Life in Pettis County: 1815–1973*. She died in 1996 at age 93. (Courtesy of Sedalia Public Library.)

Rose M. Nolen

Rose M. Nolen is a professional journalist who writes for the *Columbia Missourian* and the *Sedalia Democrat*. In 1989, while working for the *Columbia Daily Tribune*, the Missouri Press Association named her Missouri's best columnist. She has written for several other Missouri newspapers, including the *St. Louis Post Dispatch*. Nolen won the Governor's Award for the Humanities in 2003. She has authored several books including her latest, *African Americans in Mid-Missouri*, published in 2010 by History Press. (Courtesy of Rose M. Nolen.)

81

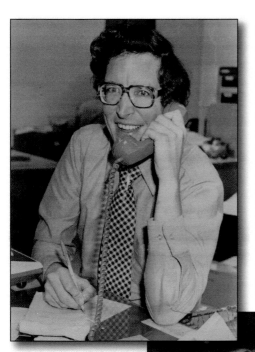

Ron Dean Jennings

At the end of the book *Charlotte's Web*, E.B. White wrote that it cannot be said of many people that they were good friends and good writers. Ron Jennings was both. Known as "Sedalia's Storyteller," Jennings was a reporter and columnist for the *Sedalia Democrat*. He enjoyed music, musical theater, barbershop singing, and college sports. While he loved people most, he also loved reading. One of his proudest moments was the publishing of his book, *Reflections and Ruminations of an Aging Rookie*. Another highpoint was being inducted into the Missouri Press Association's Hall of Fame in October 2011. Three months later, Jennings passed away after a long battle with cancer. A memorial parade following his funeral service led to a reception at the Fox Theatre—a gathering he would have loved. (Photos courtesy of Pat Jennings.)

Virginia "Ginger" Stafford Swearingen
A cofounder and board member of the Sedalia Community Theater, Ginger Swearingen was an organizer, actress, and director of many theatrical performances. She spearheaded the original fundraising for the renovation of Liberty Center and served as a member and president of the Liberty Center's board. Ginger was active in numerous other Sedalia organizations and served on their boards, including Sorosis and the Heard Memorial Club House board, P.E.O., and the Melita Day Nursery. A trustee of the May H. Ilgenfritz Trust from 1998 until her death in 2008, Ginger interviewed students and awarded college scholarships. She had a personal interest in recipients as she followed the progress of their education. She was an officer and chair of the board of the J.A. Lamy Manufacturing Company and Elliot Management Services. She was also a licensed pilot and served on the airport board. (Courtesy of H.W. Swearingen.)

Barbara Lamy Cooney
Barbara Cooney has championed creative education through the arts in Missouri. A teacher and an artist, she was a founding member of the Scott Joplin Ragtime Festival, Sedalia Area Council for the Arts, Sedalia Visual Art Association, and Camp Blue Sky. She established the Barbara Lamy Cooney Endowment for the Arts in 2003 and has contributed to State Fair Community College's theater, Daum Museum of Contemporary Art, and Heckart Science and Allied Health Center. She is pictured above with her husband, James. (Courtesy of Barbara Cooney.)

Myrna Miller Ragar
Widely known for her portraits of homes, businesses, churches, and historic sites, Myrna Ragar has exhibited professionally in many national and multi-state art shows. Her art appears on prints, ornaments, and other commemorative items. In 1983, she founded Ragar Banners by Design, which serves clients worldwide—and even in outer space, when a Ragar banner orbited with an astronaut. (Courtesy of Myrna Ragar.)

Lewis Pete Andrews Jr.
A native Sedalian with family roots dating to the 1860s, Lewis Peter Andrews made an indelible impression on his hometown. His architectural designs include Garst's Drive In and the G&G Veterinary Clinic building and several hospitals in Missouri. Andrews earned a master's of architecture degree from Washington University in St. Louis and studied at Ecole Des Beaux Arts in Fontainebleau, France. He passed away in 1996. (Courtesy of Lewis P. Andrews III.)

Douglass Freed (OPPOSITE PAGE)
Douglass Freed, an acclaimed landscape artist, was invited to develop the art department at State Fair Community College when it opened in 1968. He chaired the program until becoming director of the Daum Museum of Contemporary Art in 2000. Freed, who retired from the Daum in 2007, travels internationally, using photographs he takes as sources for his work. His paintings are nationally represented in the public collections of more than 75 museums and corporations. (Courtesy of Douglass Freed.)

J.T. Ghosen

In 1927, J.T. Ghosen opened the Star Theatre in a store building converted for stage shows. But Ghosen longed to build a theater from the ground up—and he did. The $50,000 Uptown Theatre opened in 1936. He also opened the 50 Hiway Drive-In in 1949 and acquired the Fox Theatre. Following J.T. Ghosen's death in 1974, his daughter Margie Ghosen Wagenknecht and her family continue to provide quality movie entertainment for Sedalia. They leased the State Fair Twin Cinemas in 1976. After a tornado destroyed the drive-in theater in 1980, they constructed the Galaxy Cinema on the site in 1998. Margie Wagenknecht donated the Uptown Theatre property to Sedalia Downtown Development Inc. in 2006. The theater, with its Art Deco interior largely intact (including the mural below), is awaiting restoration and the next "feature" in its history. (Mural photograph courtesy of Meg Liston.)

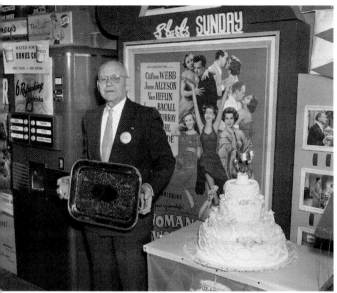

Charles King

The year the stock market crashed, Charles King became a stagehand at the Sedalia Theatre. He played the piano during the Depression to lighten the spirits of those who could spare a dime for a theater ticket. King moved to the Fox Theatre when it opened in 1940. He is pictured in 1954 when the Fox-Midwest theater group celebrated its 25th anniversary. King died in 1985 at age 93.

Edythe Ross Griffin

Silent movies were not silent when Edythe Ross Griffin provided background music. A native of Kansas City, she began playing piano at age four. She moved to Sedalia when she married attorney Frank Ross. She performed on the Sedalia Theatre's double-decker Wurlitzer organ and also played on the Liberty Theatre's organ to entertain restless children before Saturday matinees.

87

Scudda Hoo! Scudda Hay! Sedalia hosted the national movie premier of *Scudda Hoo! Scudda Hay!* At the Fox Theatre on March 10, 1948. The city afforded four Hollywood stars (Lon McCallister, Colleen Townsend, Luanne Hogan, and Betty Ann Lynn) a warm reception despite frigid thermometer readings and snow on the ground. More than 10,000 people turned out to see the celebrities in a parade downtown. (Courtesy of Sedalia Public Library.)

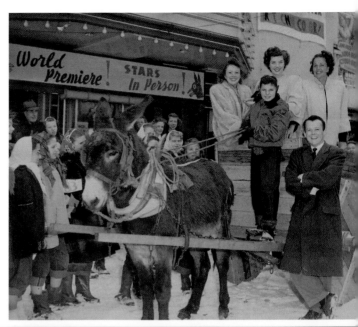

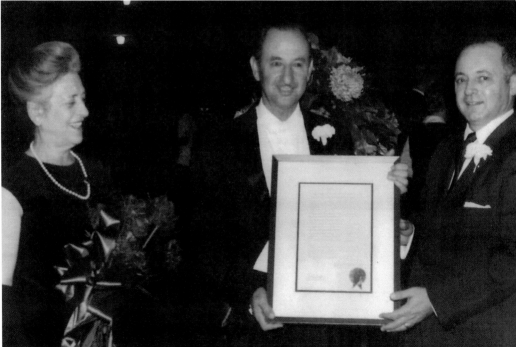

Abe Rosenthal and Harold Silberstein
Abe Rosenthal (center) was founder and conductor of the Sedalia Symphony and founder of the Sedalia Men's Choral Club. He served as lay rabbi for Temple Beth El. His wife, Fan Hanlon Rosenthal, is pictured at left. Harold Silberstein (right) was president of Sedalia Symphony and initiated the building and relocation of Temple Beth El to Dundee Avenue. He was active in the Optimists and a successful salesman for the Mutual of Omaha Insurance Company. (Courtesy of Deborah Silberstein Stoeckle.)

Anna Rose Baker
After being crowned "Jeans Queen" during the *Scudda Hoo! Scudda Hay!* Festivities, Anna Rose Baker became a professional model and television actress. A Smith-Cotton High School graduate, she has graced numerous magazine covers. In the mid-1950s, she played the title role in a television comedy series called *Meet Corliss Archer*. (Courtesy of Sedalia Public Library.)

Stuart Gressley

Sedalia media and Stuart Gressley are inextricably linked. Stu was the KMOS-TV station manager and weatherman, KSIS on-air radio personality, and *Sedalia Democrat* advertising sales representative. Active in the community, he served two terms as city councilman and supported numerous organizations. Gressley, a Vietnam War veteran, died in 2011. He is remembered for his sense of humor, love of country and family, practical jokes, and the ability to make strangers feel like old friends. (Courtesy of Madge Gressley.)

Mary Vinson

Mary Vinson published a monthly magazine, *Party Line*, and has been employed as on-air staff at KDRO radio for 18 years. The former publisher of the *Central Missouri News*, she has written recipe columns for 20 newspapers in Missouri and Kansas. She has resided in Sedalia with her husband, Russell, for 56 years. They have six children and 24 grandchildren, with whom Mary enjoys traveling and singing. (Courtesy of Mary Vinson.)

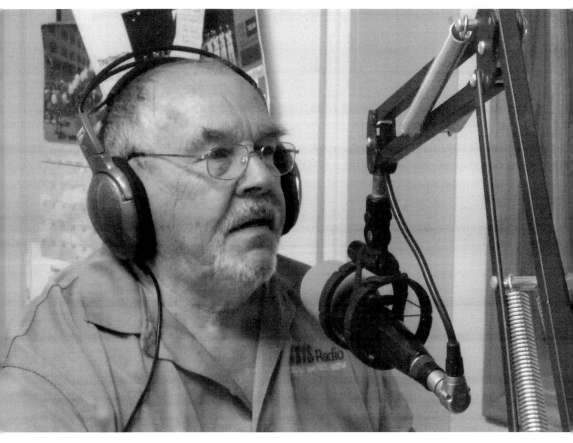

Jackie Eugene Miller
Jackie Miller's career has spanned from ocean waves to airwaves. He joined the US Navy at age 17, serving on destroyers for most of his service. After retiring from the Navy, he began writing for publication. He since has written two books, *Unhurried Days* and *Looking Back Again*, and has published numerous newspaper and magazine articles. He currently is a newsman and talk show host at KSIS radio. (Courtesy of Jackie Miller.)

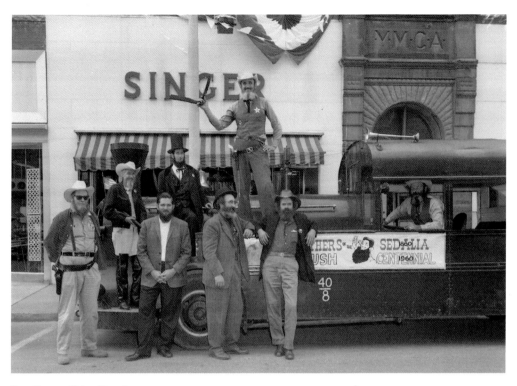

Brothers of the Brush
A group of beard-growing, law-enforcing men took the moniker "Brothers of the Brush" during Sedalia's 1960 Centennial Celebration. They fined—and even jailed—those who did not grow a beard or purchase shaving permits. Several of the "Brothers" posed with their float, which won third place in floats in the centennial parade. Pictured are, from left to right, unidentified, Rosie Ellis, unidentified, Slim Osborne, unidentified, Verrel Martin, unidentified, and Barney Ragar.

Centennial Queen Candidates
While centennial men were "brushy," centennial women were beauties. Queen contestants gathered at the Old Missouri Homestead Restaurant. From left to right are Myrna Miller, Sandra Hammond (later crowned Miss Sedalia Centennial), unidentified, and Priscilla Ellis. Some women also joined the "Sisters of the Swish," easily recognized by their sweeping long dresses and bonnets.

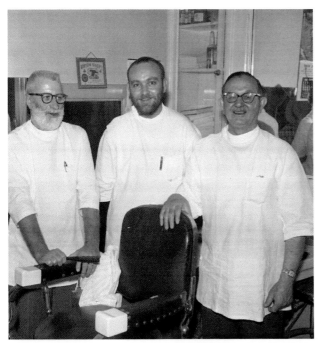

Centennial Beard Contest
The Brothers of the Brush added $3,500 to centennial coffers by selling shaving permits and collecting jail fines. While they were dedicated to the cause, they were eager to rid themselves of beards as soon as the centennial was over. Standing by with razors were, from left to right, Frosty Dill, Howard Nichols, and Brian Burke in the Bothwell Hotel barbershop.

Sesquicentennial Beard Contest
Sedalia's sesquicentennial had more in common with its centennial than a beard-growing contest. Stan Ragar, who served as the official sesquicentennial barber, apprenticed under centennial barber Frosty Dill of the Bothwell Hotel barbershop. Another centennial barber, Howard Nichols, later worked for Ragar. Ragar is shown trimming the sesquicentennial beard contest winner: Bruce Enrietto, or "Bruce in the Morning" of KXKX-FM (KIX 105.7) radio. (Courtesy of Myrna Ragar.)

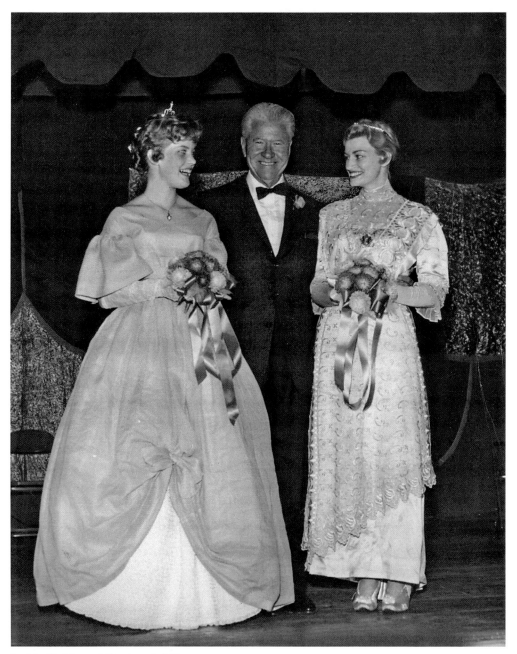

Jackie Oakie and Centennial Queens

Film star Jack Oakie returned to his hometown for Sedalia's centennial in 1960. He crowned centennial queens Sandra Hammond (left), Miss Sedalia Centennial, and Helen Eschbacher, Mrs. Sedalia Centennial. Oakie was born in Sedalia in 1903 as Lewis Offield. He starred with Ginger Rogers, Shirley Temple, Clark Gable, Loretta Young, Charlie Chaplin—and even Rin Tin Tin—during his 40-year film career. (Courtesy of Sedalia Public Library.)

Square Dance Fever
Damon Hieronymus helped fuel what was known as a square dance "epidemic" in Sedalia. The Sedalia Square Dance Association offered its first lessons in 1952, nearly reaching capacity with 72 couples participating. Hieronymus, who frequently "called" square dances, is standing in back next to Virginia Flower. (Courtesy of John Simmons.)

Damon Hieronymus
Damon Hieronymus began his career in retail sales. His parents, Charles J. and Carrie Hieronymus, owned the Elite Shop in downtown Sedalia. Hieronymus was a buyer for his parents' business until he served in the Air Force during World War II. He returned to Sedalia in 1945 and became vice president of the C.W. Flower Company. Hieronymus remained with Flower and was chairman of the board when it closed in 1990. (Courtesy of John Simmons.)

Mabel DeWitt

Generations of Sedalians studied piano with Mabel DeWitt. She began piano lessons at age five with Anna Mertz Bard and later studied at the Chicago Musical College and the Julliard School in New York. "It is a supreme joy to help them explore the beauty of the art to which I have devoted my life," she said of her students. She passed away in 1964. (Courtesy of Sedalia Public Library.)

Helen G. Steele Music Club

Members of the Helen G. Steele Music Club presented a Christmas program at Fox Theatre in 1947. Pictured are, from left to right, (first row) director Eva Johnson and accompanist Lillian Fox; (second row) Evelyn Beach, Vineta Hunt, Tillie Brateen, Lorraine Cross, unidentified, Maybelle Beach, Betsy Evans, Florence Demand, Margaret Potts, and Mary Faulkner; (third row) Margaret Liebel, Marion Studebaker, Estine Miles, ? Scotten, and Della Gasperson.

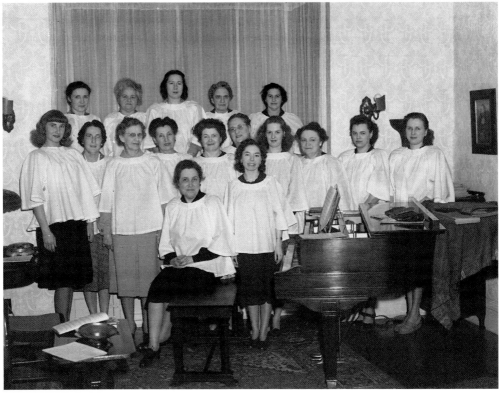

Sedalia Boys Band

Dr. J.E. Cannaday conceived a boy's band in the 1920s to provide a positive influence for youth. He explained, "A boy who blows a horn never blows a safe." Stanley Shaw and Guy Peabody founded the band, which was directed by John deYoung. Featuring 175 boys aged 6 to 16, it became the official Missouri State Fair Band and also performed for the American Royal. Samuel "Buck" Dameron was its drum major.

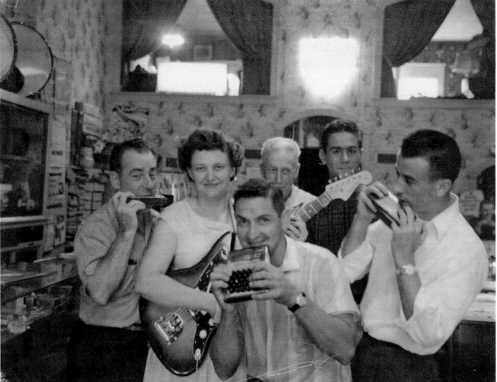

Ruth Bockelman

When the Harmonicats breezed into downtown Sedalia's Shaw Music Company, Ruth Bockelman grabbed her guitar and jammed with the famed recording artists. Bockelman began teaching for Shaw Music in 1957 and continues to give private guitar, mandolin, banjo, and accordion lessons. Many of her students are adults, including the author of this book. Also pictured with the Harmonicats are Orville Shaw (third from left) and David Turner (fourth from left). (Courtesy of Ruth Bockelman.)

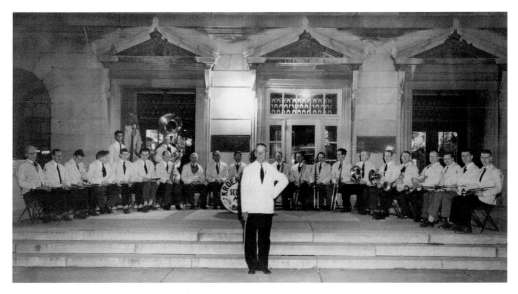

Kroencke's Band
Henry H. Kroencke's band was a Sedalia staple for decades. Pictured with Kroencke are, from left to right, (first row) Carson Meredith, J.R. Deming, Rick Fullerton, Bob Schulz, Will Buhlig, Charles Green, L.C. Judd, Howard Brown, H.E. Schwenk, C.V. Cole, Fred Brink, Leo Eickhoff, Fred Anton, Harry Trotman, W.B. Mountjoy, Rudolph Grother, Charles Plumlee, H.H. Boatman, Kenneth Davis, Chester Eding, and Lloyd Knox; (second row) Marion "Jake" Siragusa and L.H. Kroencke. (Courtesy of Jane Harris Yount.)

The Golden Entertainers
Music, dance, skits, and musical instruments made from kitchen utensils were a winning combination for the Golden Entertainers, who volunteered their time and talent for nearly two decades. From left to right are (first row) Marie Dabner, Melva Gehlken, Maudie Britz, Irene Belker, Mary Jeanette Hurt, Rosa Dove, and Diane Zinn; (second row) Ceceilia Gerke, Georgia Quint, Hazel Richardson, Helen Robb, Marge Kruse, Delores Bryant, Mary Frances ?, Jerry Smith, Sandy Sealer, Bonnie Brown, and Lucy Cook. (Courtesy of Marie Dabner.)

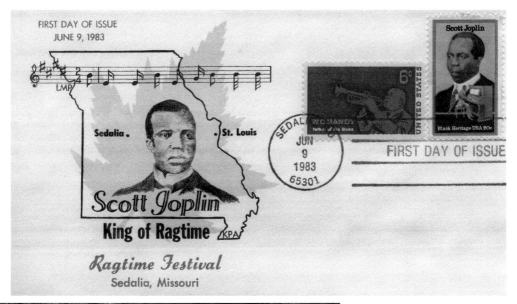

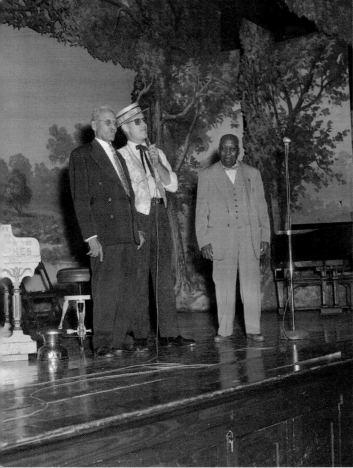

Scott Joplin

Hailed as the "King of Ragtime," Scott Joplin published the "Maple Leaf Rag" in Sedalia in 1899. More than a century later, ragtime still rings on Sedalia streets. Sedalia has hosted the Scott Joplin International Ragtime Festival annually since 1983. The US Postal Service issued a 20¢ postage stamp featuring Joplin, part of its Black Heritage USA series, in conjunction with the occasion.

Ragtime Legends

The headliners at the 1959 Scott Joplin Memorial Concert had strong ties with Joplin. Tom Ireland (left) played clarinet with the Queen City Band, as did Joplin. Ragtime Bob Darch (center) is credited with reviving ragtime interest in Sedalia and was a long-time performer at Scott Joplin Festivals. Joplin lived for a time in the home of Arthur Marshall (right), who himself was a ragtime composer.

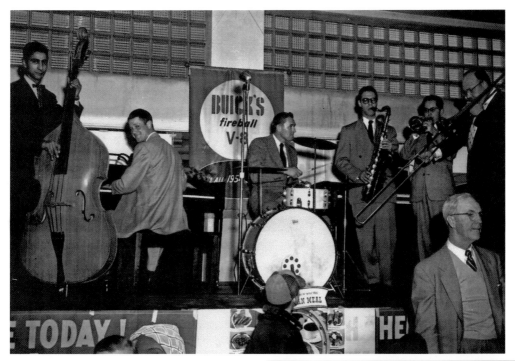

Marion "Jake" Siragusa
Born in New York, Jake Siragusa (left) was
stationed at the Sedalia Army Air Field during
World War II. He became active in Sedalia
music, including Harry Trotman's dance band. He
and Trotman opened the Harjak Music Company
in 1949. Siragusa is also known as "Papa Jake" of
the popular donut shop he founded with his wife,
Stella, in 1963. He is pictured in 1954 with Bob
Garrett, Bob Cummins, George Young, Dr. Dave
Robinson, and Harold Bamburg.

Leroy Van Dyke
Inspired by the auctioneering career of fellow
Pettis Countian Ray Sims, Leroy Van Dyke wrote
and recorded the multi-million selling song
"Auctioneer." He recorded "Walk On By" in
1961, which *Billboard Magazine* named the biggest
country music single in history. He starred in
the movie "What Am I Bid?" and hosted his
syndicated television series, *The Leroy Van Dyke
Show*. Van Dyke returned to Pettis County
from Nashville in 1988 and continues to tour
and perform.

Andreas G. "Andy" Kostelas
After graduating from Smith-Cotton High School and serving in the military, Andy Kostelas (right) studied music at the University of Southern California. He became a Hollywood studio musician, working with Frank Sinatra, Jack Benny, the Carpenters, Barbra Streisand, Michael Jackson, and the Beatles. He also contributed to soundtracks for major movies and authored music books. He is pictured with television personality Merv Griffin while performing with the Freddy Martin Band. (Courtesy of Andy Kostelas.)

Mary Frances McCurdy Herndon
International whistling champion Mary Frances Herndon has disproven the adage "Whistling girls and crowing hens always come to some bad end." She taught herself to whistle with her grandfather's encouragement. She listened to birds and recorded whistlers—and eventually made her own recordings. A two-time Women's International Whistling Champion, Mary Frances's other honors include the Whistler's Hall of Fame and Whistling Entertainer of the Year.

John Tillman "Bud" Thomas
After graduating from Smith-Cotton High School, John Tillman "Bud" Thomas signed with the St. Louis Browns and played his first big league game with the team in 1951. The major league shortstop traded baseball for academia in 1954 when he began his teaching career at Horace Mann Elementary School. He became Heber Hunt Elementary School's first principal when the school opened in 1962. In 2012, to celebrate Heber Hunt's 50th anniversary, Thomas threw out an opening pitch on the first day of school. The Sedalia Merchants pictured in 1946 are, from left to right, (first row) William "Doc" Bess, Gabby Ellsworth, Bud Thomas, Gene Mays, James A. "Salty" Schumaker, and unidentified; (second row) H. Green, Bus Livengood, John A. Thomas (Bud's father), Raymond Morris, Palmer Nichols, Harry Light, and unidentified. (Courtesy of Bud Thomas.)

Ross Dey

The softball glove and ball atop Ross Dey's tombstone at Crown Hill Cemetery represent a legendary athlete. Dey was a member of US Olympic fast pitch softball team, where he earned a gold medal. He was inducted into the Missouri Sports Hall of Fame and the Missouri High School Baseball Coaches Association Hall of Fame. He was a member of the Missouri State High School Athletic Association and served as a coach for the American Legion baseball team. Dey began his teaching career in the Malta Bend School District, and in 1988, became a teacher and coach for the Sedalia School District. He was Smith-Cotton High School's head baseball coach for 18 years. Dey died in 2009 after a three-year battle against cancer. In 2011, the Liberty Park Stadium ballfield was renamed Dey Field in honor of him and the Dey family. (Photographs courtesy of Amy Dey.)

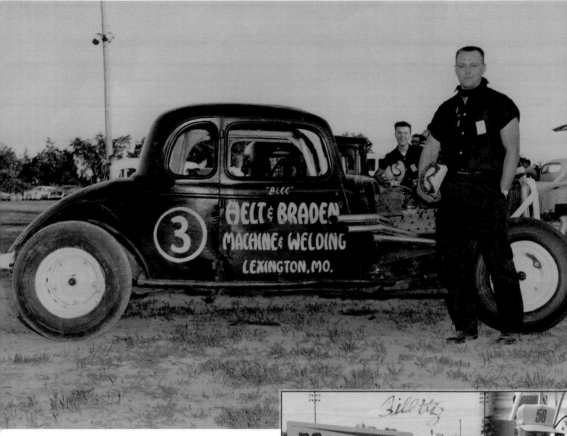

Bill Utz

Horseshoes brought legendary Bill Utz to Sedalia. He traveled the Midwest as a farrier and became the official Missouri State Fair farrier. He built his first racecar in 1958 (above), a modified 1934 Ford. It was number "Circle 3" because he was $3 short of paying for it. His racing career took off in 1963 when he won 23 feature events. In the following years, Utz traveled, racing in many different associations. He recorded 347 feature wins, seasonal point championships, and three IMCA point championships. He was installed in the Knoxville Hall of Fame in 1982. His car "Ole Yeller" (right) was placed in the National Sprint Car Hall of Fame in 1991, and Utz was inducted in 2003. When not racing, he found time to own the Quality Body Shop, Shel-Rae Dairy Cup, Pit Stop Cafe, 65 Speedway, and State Fair Amoco. (Photographs courtesy of Bill and Joy Utz.)

CHAPTER FIVE

Service and Freedom

Sedalians take their civic responsibility seriously. In fact, three months after the first train roared through the new city, Sedalians shouldered up for the Civil War. Citizens turned from erecting buildings and opening businesses to serving their country. One historian notes, "The war had advanced with such intenseness and rapidity that after the first three months all improvements stopped." This outward focus has characterized Sedalia throughout its history. In peacetime as well as war, Sedalians have represented their city, county, and state through political service. They have taken an active part in philanthropic and social organizations that work in a myriad of ways to improve the community and quality of life for individuals. These legendary locals are not limited to those who appear in history books. They are alive and well, continuing to make history each day, going about their daily lives, as they serve their community and country.

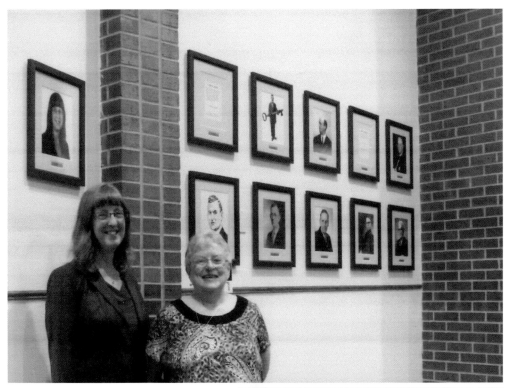

Elaine Horn and Jane Gray
Sedalia's two women mayors in its 152-year history were present at the unveiling of a historical photo gallery at city hall. Mayor Elaine Horn (left) took office in 2009. Jane Gray served as mayor from 1991 to 2002. City Clerk Arlene Silvey and City Administrator Gary Edwards originated the idea for the display, which includes portraits or biographical information about Sedalia's 48 mayors. It was dedicated in August 2012. (Courtesy of Joleigh Melte.)

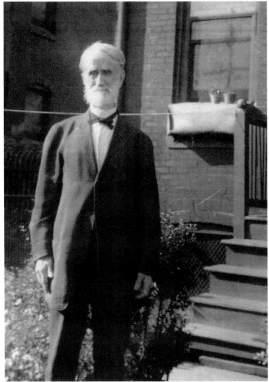

George W. Cummings
Exactly 100 years after Sedalians elected George W. Cummings as mayor, they broke ground for a new municipal building to replace the city hall where he had presided. Cummings, born in 1838, was mayor from 1872 to 1873. He was an attorney and officer of the Sedalia Foundry. Cummings moved from Sedalia in 1902 and "returned" in 2012 when his photograph became part of a historical gallery at city hall. (Courtesy of Carol Barbee.)

Eugene Couey
In 1925, Probate Judge Eugene W. Couey conducted the first wedding in the then-new Pettis County courthouse. Judge Couey was clad in overalls and arranging furniture in his new quarters when William Scott and Bertha Humphrey requested his services. Born in 1866, Judge Couey served as city attorney, probate judge, and prosecuting attorney, as well as a four-term representative in the Missouri legislature. He died in 1972 at age 105.

Hazel Palmer
The daughter of Congressman John W. Palmer, Hazel Palmer moved to Sedalia at age seven. She joined her father's law practice after receiving her law degree in 1932. She became the first female assistant prosecuting attorney in Pettis County and is listed in several volumes of "Who's Who," including "Who's Who in America." She died in 2002 at age 98. (Courtesy of Sedalia Public Library.)

James L. and Doris Mathewson

Sen. James L. Mathewson was first elected to serve in the Missouri House of Representatives in 1974. After being reelected to the House twice, he was elected to the Missouri Senate in 1980. He served the Senate for 24 years, including four years as the majority floor leader. He holds a record as the longest-serving state president pro tem in Missouri history. The James L. Mathewson Exhibition Center was named in his honor after he supported a voter-approved bond issue to create Missouri job growth, which included funds for the facility that attracts events to the fair year round. State Fair Community College was another priority during Mathewson's political career. It became the first Missouri college to receive state funding for capital improvements. In addition to his political service, Senator Mathewson owned restaurants, broadcasting, and appraisal industries. Doris Mathewson's community support includes service as president of the Sorosis organization. (Courtesy of James and Doris Mathewson.)

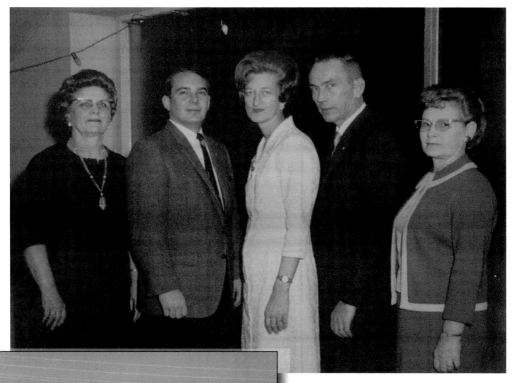

Roger Garlich and the Crippled Children's Center

The Crippled Children's Center originated in 1955 from an unexpected meeting around a parking meter. Three attorneys, raising money for three separate crippled children's organizations, happened to meet in front of Sedalia Bank & Trust. Placing elbows on the parking meter, they realized the community could be better served by combining forces. That parking meter is now part of the History Room in the Roger A. Garlich Center. Garlich (pictured on the horse) began working for the Crippled Children's Center in 1961 and in 1966 helped form the first sheltered workshop in Missouri. In the above 1966 photograph are, from left to right, Lucille White, Roger Garlich, Mary Kay Hunter, Fred Keane, and Anna Pangburn. Garlich retired in 2009 and continues to serve as a consultant. Now known as the Center for Human Services, the organization serves more than 2,000 adults with disabilities and their families in more than 30 counties in central Missouri. (Both photographs courtesy of Children's Therapy Center.)

Hats off to you! Boss's Day 2002

Anna Lee Bail

From ringing bells for the Salvation Army to providing transportation for Scott Joplin performers, from selling Missouri State Fair souvenirs to serving tea at the Katy Depot, Anna Lee Harvey Bail is known as a "tireless volunteer." In 2010, the Sedalia Blue Ribbon Steering Committee honored Bail for exemplifying the Blue Ribbon Vision of making "Sedalia the Blue Ribbon place to live, to work, to learn, and to visit." Bail's service includes mission trips, Habitat for Humanity, Open Door Ministries, Bothwell Regional Health Center, First Baptist Church, the Community Café, Retired and Senior Volunteer Program, PTA, and 4-H.

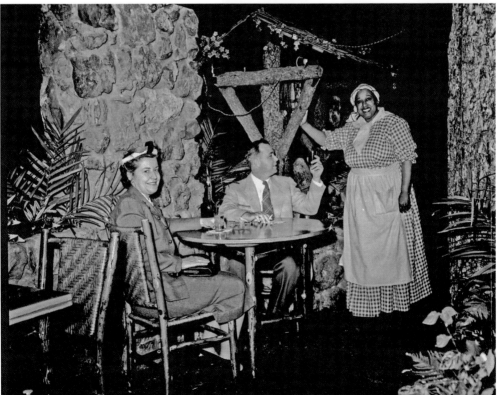

Vivian Warren

A part-time job led to 25 years of service for Vivian Warren (left), who served as secretary of Sedalia's Chamber of Commerce from 1951 to 1976. She treated those who requested information about Sedalia as "future citizens," prompting several to relocate to the city. Her work received national recognition through "Who's Who in America." She is pictured at the Old Missouri Homestead Restaurant in 1954, when "Aunt Jemima" visited Sedalia.

Jaycees

The charter for Sedalia's Junior Chamber of Commerce, or Jaycees, was presented in May 1950. The organization provided leadership and service opportunities for men and their wives between the ages of 21 and 36. Sedalia leaders at the head table included Mary Hathaway, Mary Studer, Mayor Herb Studer, Peggy Wall, and Jaycees president Bob Wall. Six months later, the Jaycees worked with a professional company to produce one of Sedalia's most memorable Christmas parades, complete with live animals. The parade is pictured below, looking south on Ohio Avenue from Fifth Street. Through the years, the Jaycees also sponsored races and rodeos.

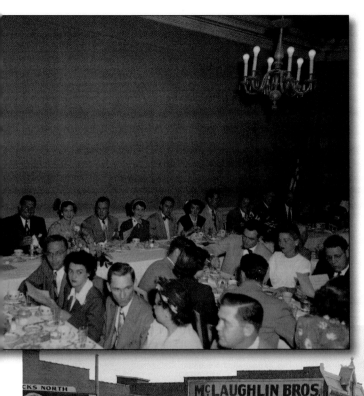

Optimist Club

Mayor Julian Bagby proclaimed November 7–12, 1948, to be Optimist Week in Sedalia, highlighting the club's work in preventing juvenile delinquency and molding Sedalia youth in good sportsmanship and citizenship. Activities included an Opti-Miss contest in which 25 teens competed based on poise, personality, appearance, and apparel. Bobbie Rice was chosen winner, with Jean Wodicka, Betty Brown, and Ann Renfro attendants. The club also had an Opti-Mrs. organization during this era.

Kiwanis

Arthur Klang (right) helped organize Kiwanis Kids' Day celebration in 1949. Sedalia's event was held in conjunction with the first National Kids' Day, designed to combat juvenile delinquency and provide educational, medical, and recreational facilities for "kids." More than 1,100 Sedalia kids participated in a parade in downtown Sedalia, a bicycle-decorating contest, and movies at the Uptown Theatre and Hubbard High School.

Lions Club

This group of men went to great lengths—or in some cases, great shorts (as in skirts)—to raise funds for worthy causes. "The Fashion Lions of '53" at the Liberty Theatre featured Lions Club president and district governor D. Kelly Scruton. Shown near center in a grass skirt, Scruton reportedly "outwiggled any hula dancer that ever wiggled" in the "Waikiki Wacky." The club later staged a similar event called the "He-Male Follies."

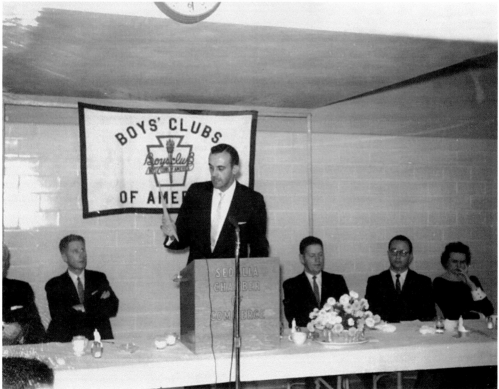

Bud Brown and the Boys' Club

John "Bud" Brown (center) of the Rotary Club was elected chairman of a group of Sedalians interested in starting a local Boy's Club of America. Chartered in 1960, the club was initially open to boys ages 8 to 18. It changed its name to Boys and Girls Club in 1990 when it welcomed females. Now known as the Boys & Girls Club of West Central Missouri, the organization serves youth in Sedalia and surrounding areas.

Girl Scouts
More than 200 people attended a Girl Scout Fly-Up Ceremony in May 1950 at the Sedalia Armory. Sixty Brownies "flew up" from Brownie Scouts to Intermediates. Troop 7 of Whittier School assisted Hazel Bowman and Earlene Goodpasture with the ceremony. Betty Wells was troop leader for the Whittier School group.

Boy Scouts
Boy Scouts unveiled the Statue of Liberty replica on the Pettis County courthouse lawn on July 4, 1950. The statue was erected through a cooperative effort of Sedalia Boy Scouts and Sedalians who contributed money as well as in-kind labor. Pictured at the excavation are, from left to right, Frank Evans, Richard Stohr, Harry Naugel, Duane Guymon (front), Z. Lyle Brown (back), Rev. A.J. Brunswick, W.C. Wallace, O.W. Wiley, Percy Shackles, and Leo Bottcher.

Business and Professional Women
Sedalia's Business and Professional Women (BPW) organization was founded in 1923. Pictured in 1964 are, from left to right (first row) Vivian Warren, Mary Whiteside, Lily Thomas, Myra Price, Virginia Gilpin, and Marjorie Weber; (second row) Marguerite Scott, Edna Mae Kirchhofer, Margaret Ferguson, Lou Scotten, Erna Ann McClure, Lila Deal, Evelyn Staples, and Sue Heckart; (third row) Mary Kay Hunter, Marjorie Garansson, Mildred Bowman, Marian Laudenberger, Mary Gardner, and Bessie Perkins. The organization is now known as the Sedalia Business Women.

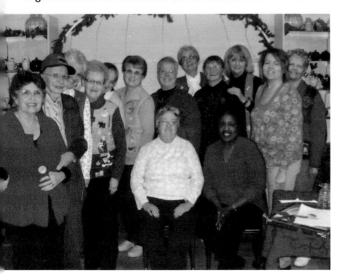

American Business Women's Association
Sedalia's American Business Women's Association (ABWA) was formed in 1952. Pictured are group members at a Christmas meeting, held at the Ivy Cottage Tea Room. From left to right are (first row) Carol Kennedy and Estella Frazier; (second row) Myrna Ragar, Catherine Scott, Ginny McTighe, Donna Franklin, Jeanne Braswell, Lyra Rupprecht, Joyce Grinstead, Mary Merritt, Linda Waller, Michele Muin, Terri Brown, and Marge Watson. (Photograph courtesy of Michele Muin.)

Judge Donald and Carol Barnes
Journalist Ron Jennings once called
Donald Barnes "the hanging judge,"
recognizing Barnes's project to hang
portraits of all his predecessor Pettis
County circuit court judges on the walls
outside the courtroom. Judge Barnes
initiated another "hanging" in 1996,
this time launching a project to tell the
history of Pettis County through murals
inside the courtroom, completed in
2002. He served 28 years as presiding
judge of the 18th Judicial Circuit,
retiring as a senior judge in 2005. His
wife, Carol, was the first faculty music
instructor at State Fair Community
College and has sung with the Sedalia
"Messiah" since its inception, often as
a soloist. She was one of the founders
of Native American Appreciation
Day and is a past chorus director and
past president of the Helen G. Steele
Music Club. She recently received
the Valiant Woman Award from the
Church Women United, recognizing her
service to her church and community.
(Photographs courtesy of Randy Kirby
and Mark Barnes.)

Tom and Mildred Lueking Yount
Tom and Mildred Yount are remembered for their abundant energy, much of which supported the community. Tom's leadership included the First Christian Church, Kiwanis, Community Chest, the Pettis County War Bond Drive, Sedalia School Board, Salvation Army, and Sedalia Symphony. Mildred served as president of the Council of Sedalia Garden Clubs and Sorosis and on the American Red Cross and Girl Scout boards. They both were active in the Pettis County Historical Society. Mildred enabled audiences and television viewers to "visit" historic Pettis County sites through her slide presentations. (Photographs courtesy of Jane Harris Yount.)

Teddy and Marie Dabner
The word "hospitality" could have been coined for Teddy and Marie Dabner. Their home was always open to people and filled with children working on projects. They were leaders for the Striped College 4-H Club, where Teddy served as woodwork leader for more than 15 years. Both were active in PTA, Helping Hands, and other community betterment organizations. The Dabners celebrated 72 years of marriage before Teddy's death in 2008. (Courtesy of Marie Dabner.)

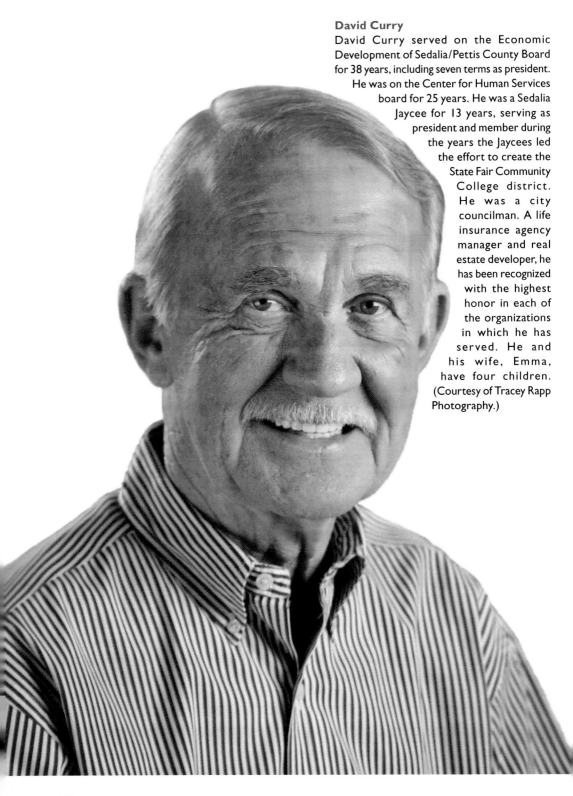

David Curry

David Curry served on the Economic Development of Sedalia/Pettis County Board for 38 years, including seven terms as president. He was on the Center for Human Services board for 25 years. He was a Sedalia Jaycee for 13 years, serving as president and member during the years the Jaycees led the effort to create the State Fair Community College district. He was a city councilman. A life insurance agency manager and real estate developer, he has been recognized with the highest honor in each of the organizations in which he has served. He and his wife, Emma, have four children. (Courtesy of Tracey Rapp Photography.)

Samuel C. Gold

Capt. Samuel C. Gold was one of 14 officers chosen as honor guard for Pres. Abraham Lincoln's body after his assassination. Gold, who enlisted to serve in the Civil War in 1861, was the youngest man to reach the rank of captain in the regular army from a private in the volunteer army. Gold founded a Sedalia lumber business that bore his name from 1872 until 1962, when Herrman Lumber purchased it. (Courtesy of Caroline Fontaine.)

Charles E. Messerly

Sedalia mayor and businessman Charles E. Messerly was a sergeant in the Sedalia Rifles, organized in 1879. The Rifles were ready to protect Sedalia when the Spanish-American War broke out. Messerly owned a dry goods store in downtown Sedalia and erected a large apartment complex known as Messerly Flats at Third Street and Kentucky Avenue. He also served as Sedalia mayor from 1882 to 1884. (Courtesy of Ralph Ludemann Wentworth.)

Clemence Kahn

Clemence Joseph moved to Sedalia in 1895 when she married Arthur Kahn. While her husband ran his family's store, she took a leadership role in the community. She organized the Sedalia Auxiliary of the American Red Cross at her home in 1914. This chapter was the first in Missouri and the first west of the Mississippi. She is pictured at left in 1917 with May Jaynes Wood, ? Lawson, and Helen Gallie Steele. (Courtesy of Jan Altshool.)

James F. and Frances Truitt Rogers

When he enlisted in World War I, James Rogers began a long-distance courtship with his "girl," Frances Truitt, back in Sedalia. He described their engagement—even wedding night!—in his military diary. They were married in 1918, just before he shipped off to France. Rogers was severely injured in the Battle of Argonne but recovered and returned home in 1919. The Rogerses' "happily ever after" ended in 1923 when Frances died in childbirth.

Johnnie Housel
On December 6, 1941, Johnnie Housel finished Christmas shopping and mailed a letter to his mother and sisters in Sedalia. He then went to bed aboard the USS *Arizona*, where he was stationed in Pearl Harbor. The ship was bombed hours later. His letter and Christmas package arrived in Sedalia after his death. "It was sad for us, but it was just like Johnnie to think of us," his sister Marie Housel Dabner said. In 2004, a street in Sedalia and another at Whiteman Air Force Base were named in Johnnie Housel's honor. (Courtesy of Marie Dabner.)

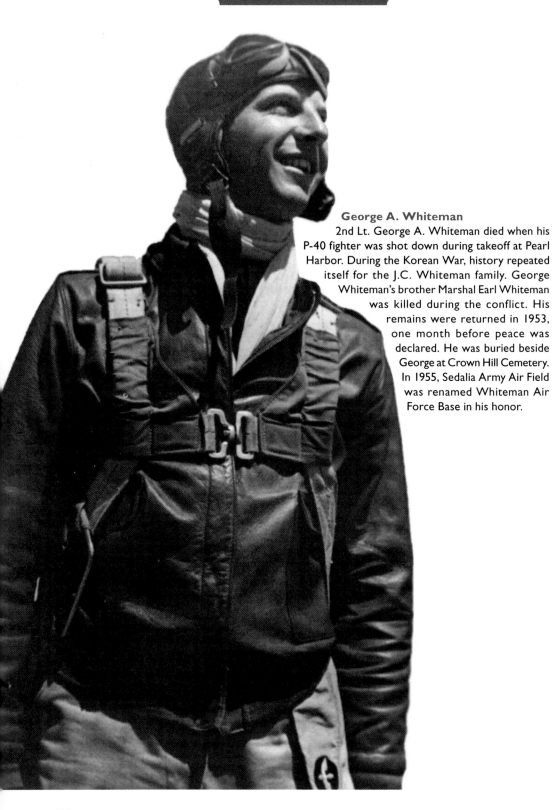

George A. Whiteman

2nd Lt. George A. Whiteman died when his P-40 fighter was shot down during takeoff at Pearl Harbor. During the Korean War, history repeated itself for the J.C. Whiteman family. George Whiteman's brother Marshal Earl Whiteman was killed during the conflict. His remains were returned in 1953, one month before peace was declared. He was buried beside George at Crown Hill Cemetery. In 1955, Sedalia Army Air Field was renamed Whiteman Air Force Base in his honor.

Maj. Gen. John C. "Jack" McLaughlin III
Sedalia's previous and current National Guard Armories were named in honor of Maj. Gen. John C. "Jack" McLaughlin III, who served with the Missouri National Guard from 1924 to 1960. When he died in 1967, he was recognized as the only officer of the Missouri National Guard in the last 100 years to be appointed directly from colonel to major general (two stars) and to be federally recognized as "General of the Line" by the US Army.

Dr. Donald and Edith Donath
More than six decades after World War II ended, S.Sgt. Donald W. Donath had a chance to "meet" Pres. Harry S Truman. Donath was a tank commander of the 20th Tank Battalion. Truman (portrayed by Raymond Starzmann) greeted Donath and his wife, Edith, at the Hotel Bothwell. The Donaths serve the community in numerous ways, especially as educators and dance instructors. Edith received the Liberty Center STAR Award and was recognized in 2012 for beginning her 77th season with the Sedalia Symphony Orchestra.

Robert E. "Bob" Wasson

Patriotism ran deep for Korean War veteran Bob Wasson (left). In addition to serving his country, he served God as an ordained minister, warmly greeted customers in his grocery store, Bob's AF Super, and was director of Sedalia Senior Center. Wasson, a native Sedalian, was a visible and dedicated servant to the Sedalia community. At the time of his death in 2009, he was serving his second term as mayor of the city.

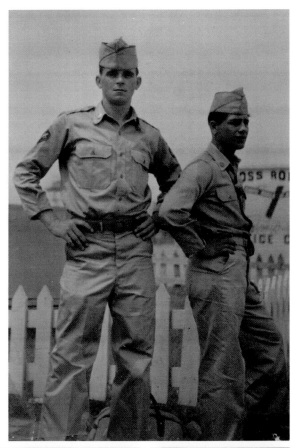

Vietnam Veterans of Pettis County

A small advertisement in the *Sedalia Democrat* led to a 14,000-pound granite monument. The ad encouraged Vietnam veterans to "unite and speak up." Thirty-five veterans responded and began to meet, agreeing to dedicate a monument to their 12 Pettis County comrades who had died during the war. Pictured are a portion of the more than 500 people who attended the 1988 dedication. Vietnam veteran Jim Gaertner is at the podium. (Courtesy of David Dieckman.)

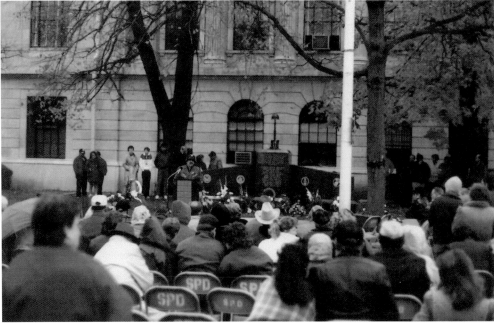

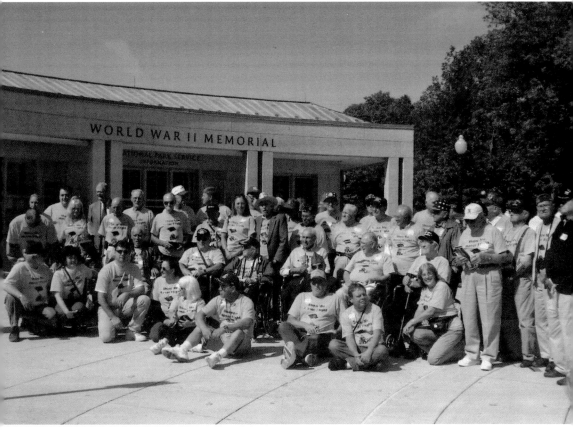

Show Me Honor Flight
Since its inception in April 2008, the Show Me Honor Flight has taken 10 groups of World War II and Korean and Vietnam War veterans to see their memorials in Washington, DC. Show Me Honor Flight No. 1 is pictured above in October 2008. Charlie Thomas and Pam Burlingame cofounded the organization after reading an article about the program in *Parade* magazine. They were especially inspired because both of their fathers served in the Navy in World War II and both died before the memorial was built. "Since the beginning, Show Me Honor Flight has been a success," Pres. Pam Burlingame states. "This community has embraced and supported our efforts for the veterans." (Courtesy of Pam Burlingame.)

INDEX